FINGER PRINT

MONSTERS AND DRAGONS

AND 100 OTHER ADVENTUROUS CREATURES

QUARRY

CONTENTS

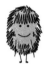

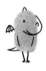

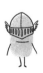
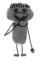

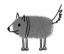
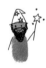
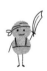
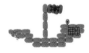
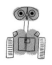

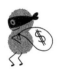
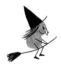
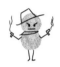
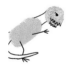
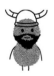

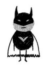

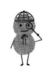
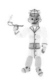

INSTRUCTIONS

FINGERPRINT CHARACTERS ARE EASY TO MAKE! HERE YOU LEARN HOW:

PUSH YOUR FINGER INTO AN INKPAD AND THEN MAKE A PRINT ON PAPER.

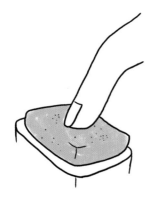

OR JUST PAINT YOUR FINGERS USING WATERCOLOR AND A BRUSH.

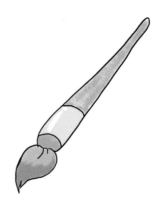

ONCE THE FINGERPRINT HAS DRIED YOU CAN DRAW ON IT USING THIN COLORED PENCILS OR A PEN.

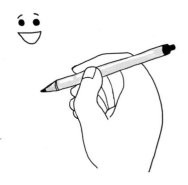

COVER PART OF YOUR FINGER WITH A PIECE OF PAPER TO CREATE HALF A PRINT.

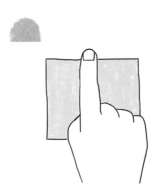

USE YOUR THUMB TO MAKE A BIG PRINT.

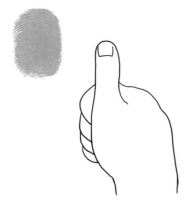

USE YOUR INDEX FINGER TO MAKE A SMALLER ONE.

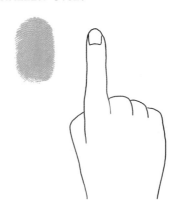

IF YOU USE YOUR FINGERTIP, YOU'LL GET A ROUND PRINT.

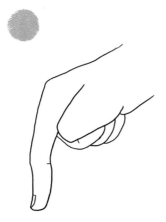

AND WITH THE PINKY FINGER YOU'LL MAKE A REALLY SMALL PRINT.

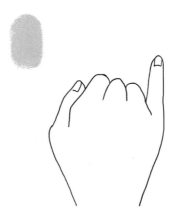

INSTRUCTIONS CONT'D

ALWAYS WAIT UNTIL THE PAINT HAS DRIED COMPLETELY OTHERWISE YOUR PICTURE WILL SMUDGE.

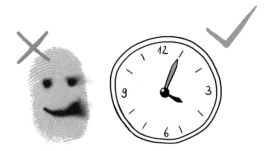

WHEN YOU SWITCH COLORS, USE A DIFFERENT FINGER OR CLEAN YOUR FINGERS THOROUGHLY SO COLORS DON'T MIX.

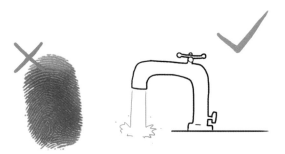

PAY ATTENTION NOT TO USE TOO MUCH PAINT OTHERWISE YOUR CHARACTER WON'T BE CLEAR.

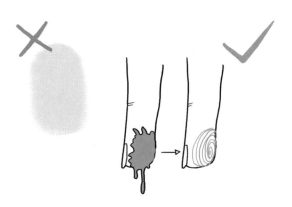

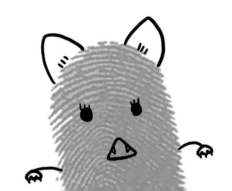

CREATE A BIG, FREE WORKSPACE WHERE YOU HAVE ENOUGH ROOM TO DO YOUR PRINTING.

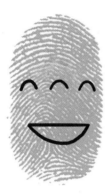

PAY ATTENTION THAT YOU DON'T PUT THE PAINT IN YOUR MOUTH.

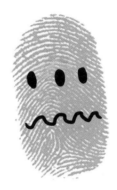

WHEN YOU ARE ALL DONE WITH YOUR PRINTING, MAKE SURE TO CLEAN YOUR HANDS THOROUGHLY WITH WATER AND SOAP.

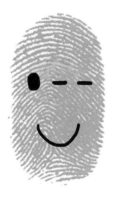

COLORED PENS MAKE YOUR CHARACTER A REAL LOOKER! WHEN YOU WORK WITH PAINT, WEAR CLOTHES THAT CAN GET DIRTY!

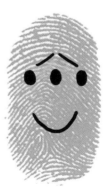

MONSTERS

MONSTERS ARE GREAT! AND THERE ARE SOOOO MANY DIFFERENT VARIATIONS:

HAPPY MONSTERS

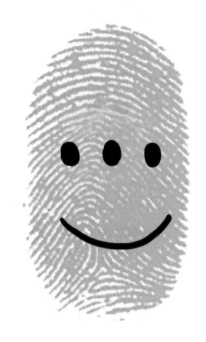 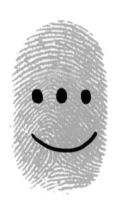

LAUGHING MONSTERS

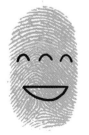 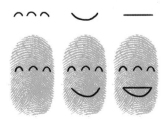

SAD MONSTERS

 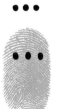 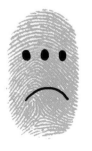 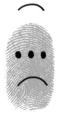

MISCHIEVOUS MONSTERS

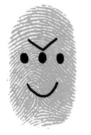

SCARED MONSTERS

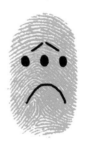 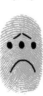

FURIOUS MONSTERS

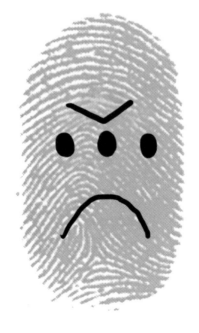 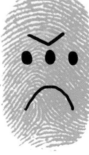 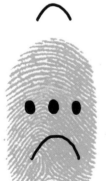

SHY MONSTERS

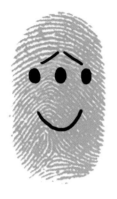

WINKING MONSTERS

 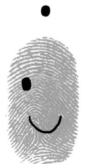 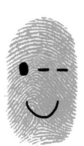

TALKING MONSTERS

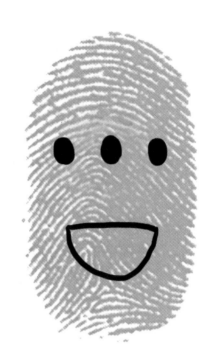
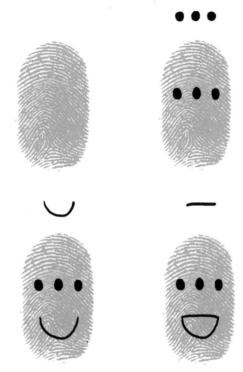

MONSTERS CAN ROAR LOUDLY.

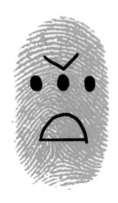
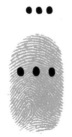
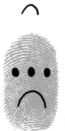
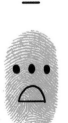
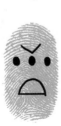

MONSTERS CAN WHISTLE, TOO.

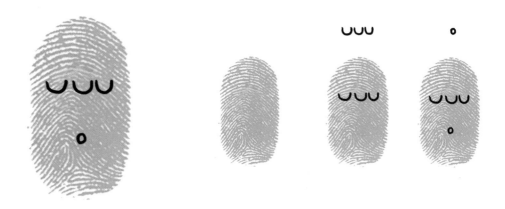

MONSTERS ARE GOOD SINGERS.

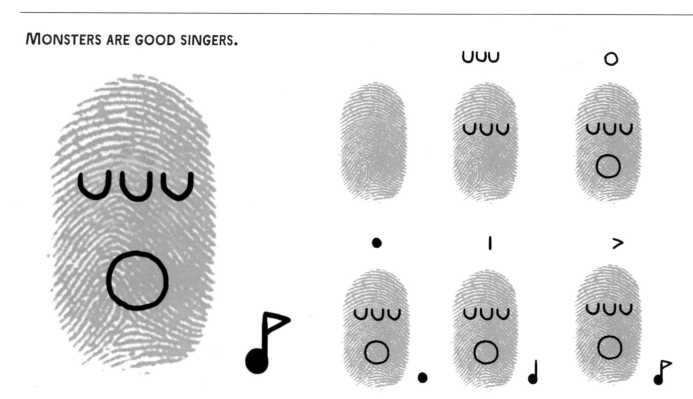

EVEN MONSTERS CRY SOMETIMES.

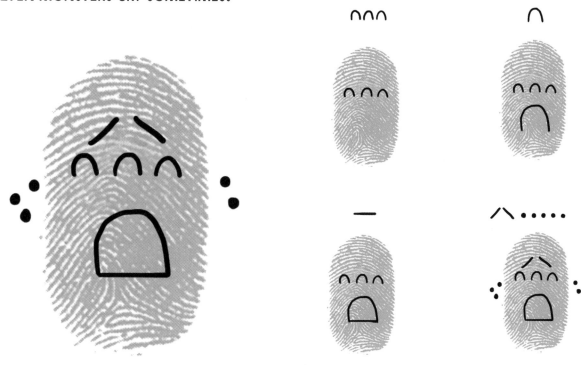

THAT'S WHAT THEY LOOK LIKE WHEN THEY HAVE BEEN FRIGHTENED.

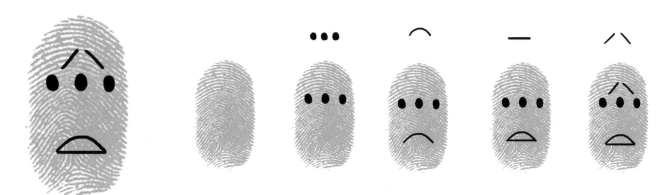

OFTEN THEY SMILE.

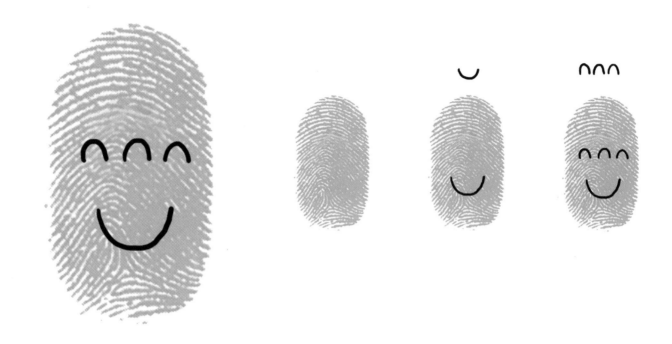

MONSTERS LIKE TO SLEEP.

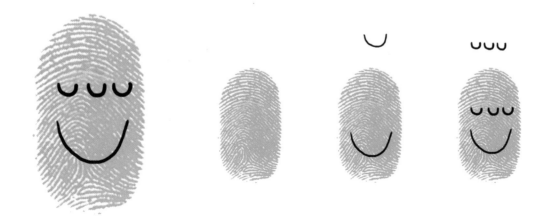

OH, THESE MONSTERS HAVE FUN MOUTHS!

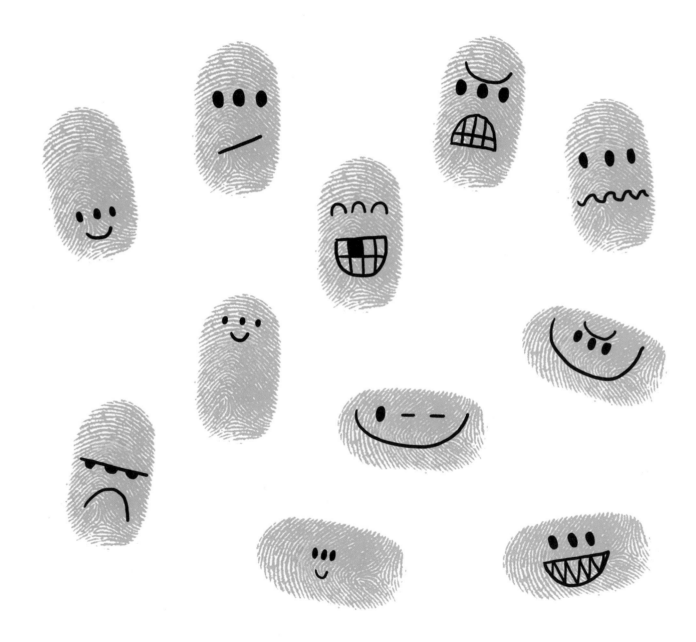

SOME MONSTERS HAVE ONLY ONE EYE.

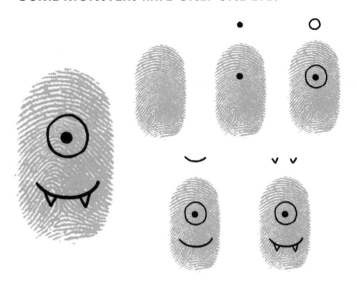

SOME HAVE A BIG EYE.

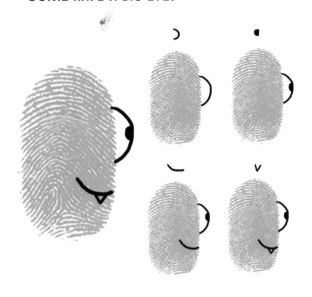

SOME MONSTERS HAVE THREE EYES...

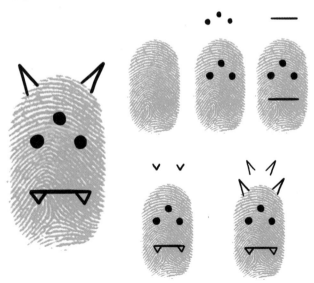

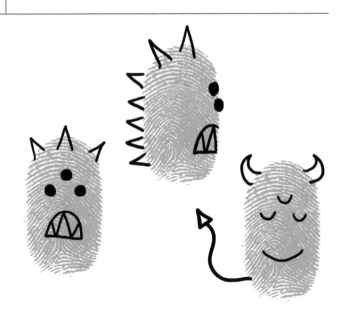

...AND LOOK AROUND WITH THEM.

THERE ARE ALSO OTHER KINDS OF MONSTERS: MUMMIES ARE WRAPPED IN BANDAGES.

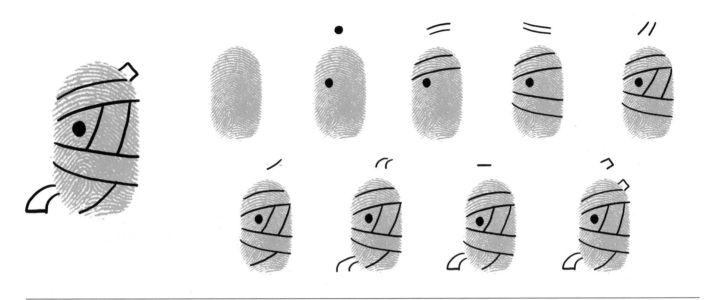

GIANT BATS HAVE EARS AND WINGS...

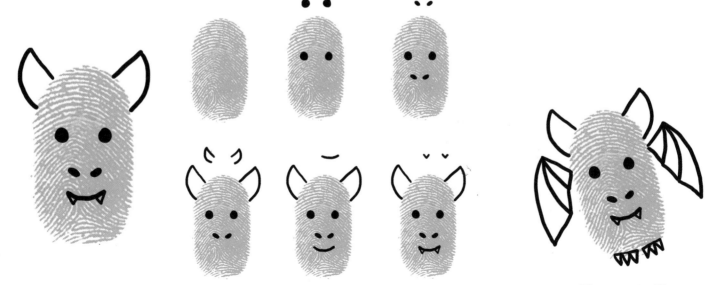

...AND WITCHES WEAR BIG HATS.

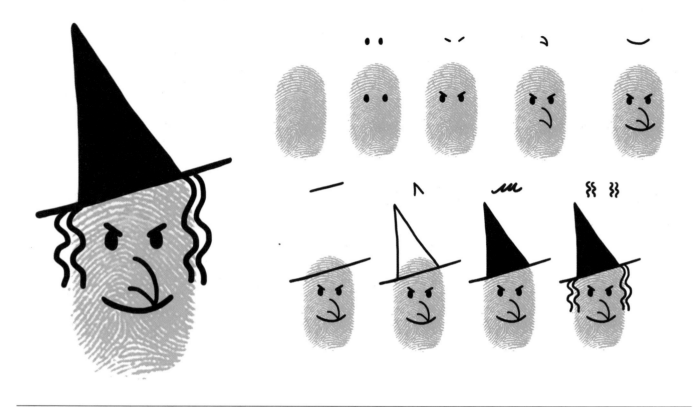

GIANT SPIDERS HAVE MANY LEGS...

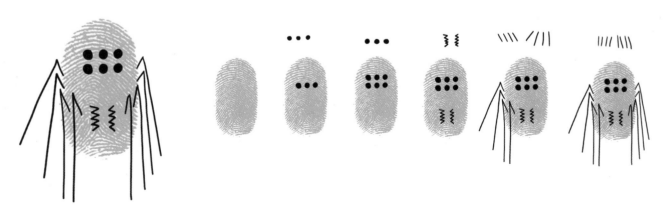

...AND TENTACLE MONSTERS HAVE A LOT OF TENTACLES

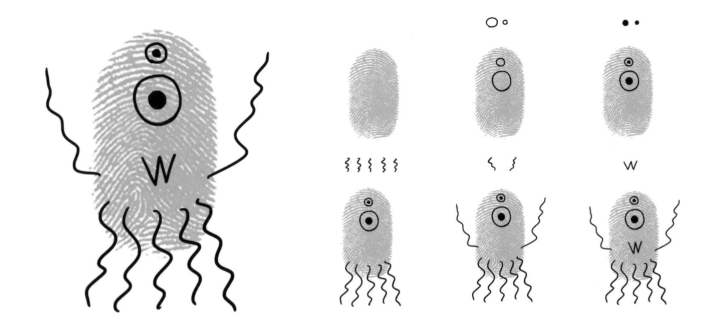

THERE ARE SOOOO MANY DIFFERENT MONSTERS.

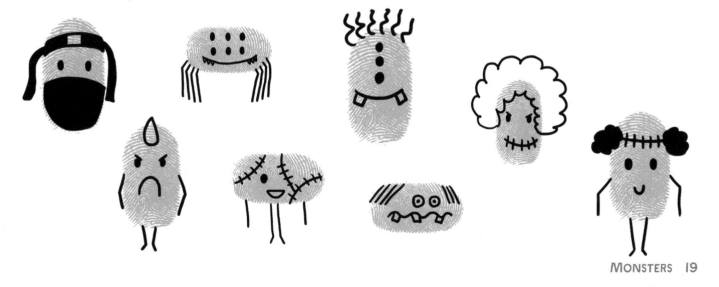

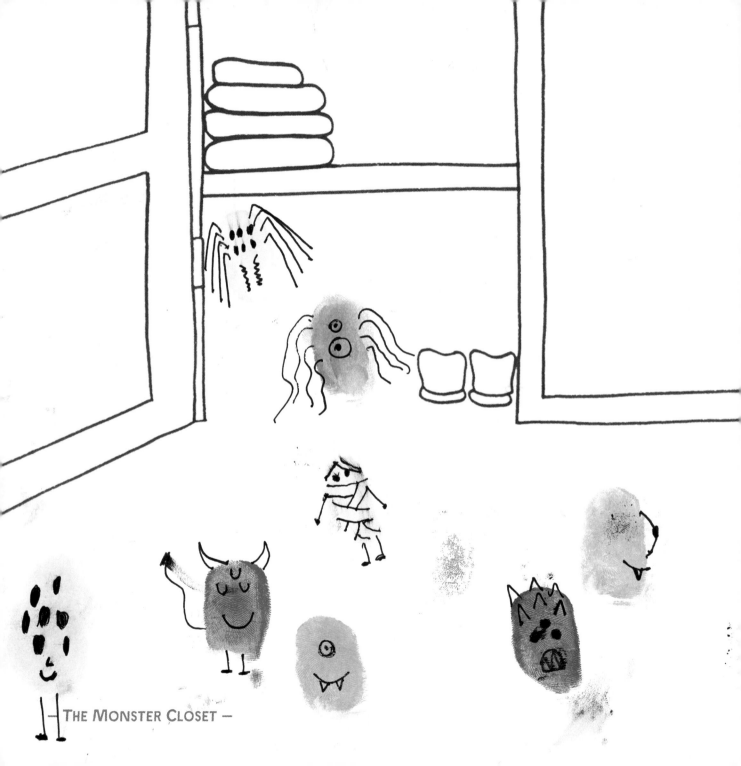

THE MONSTER CLOSET

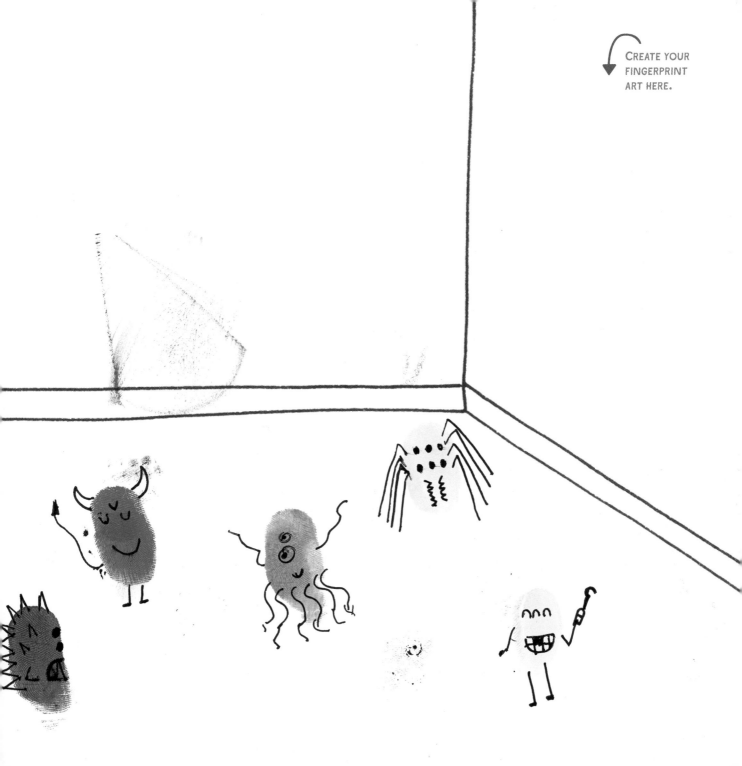

FUR & ACCESSORIES

SOME MONSTERS HAVE FUR, LONG HAIR, OR A BEARD.
THERE ARE ALSO OTHER DECORATIVE THINGS.

SMALL SCRIBBLES ARE THE BEST WAY TO CREATE HAIR, BEARDS, EARS, OR WINGS.

OR YOU CAN MAKE LINES, CURLS, AND EVEN MORE SCRIBBLES.

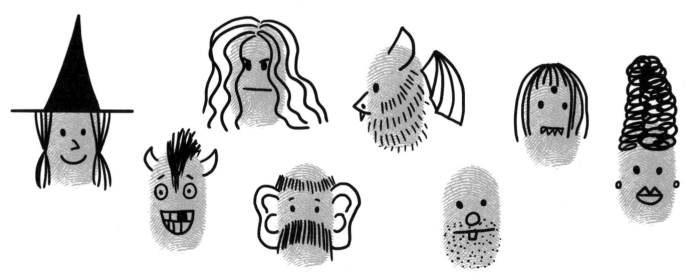

THICK FUR

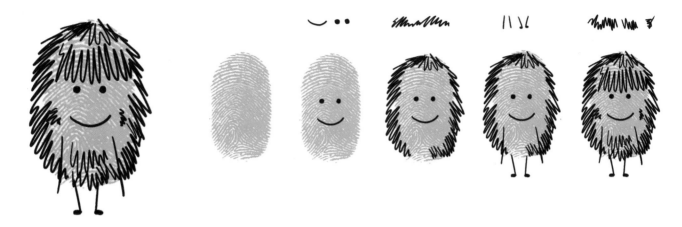

WINGS

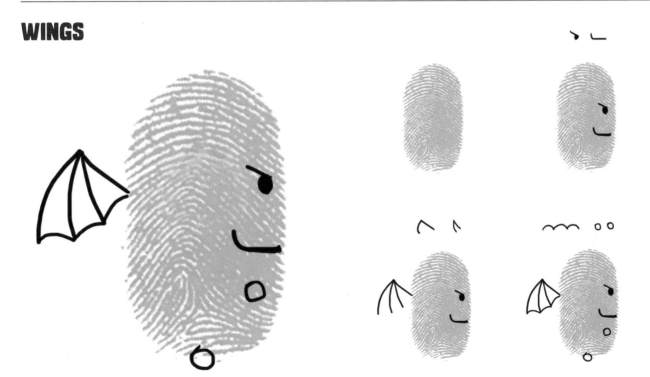

KNIGHT IN ARMOR

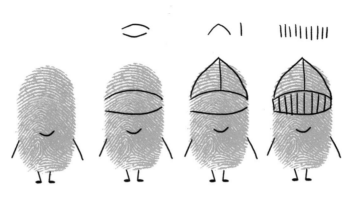

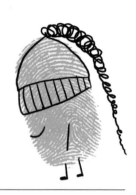

FEATHERS

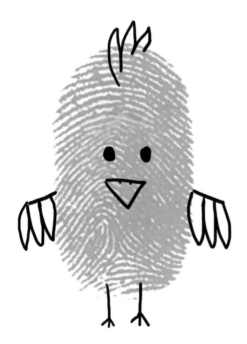

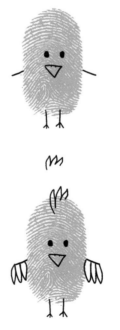

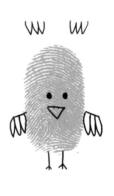

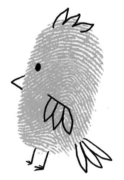

WITCH GARMENT

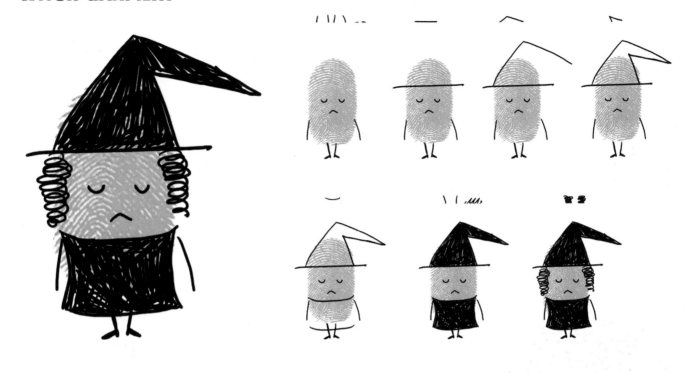

DETECTIVE'S HAT

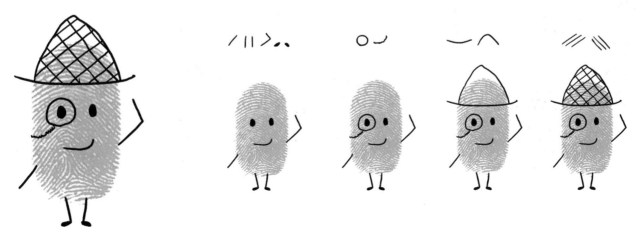

PIRATE PANTS

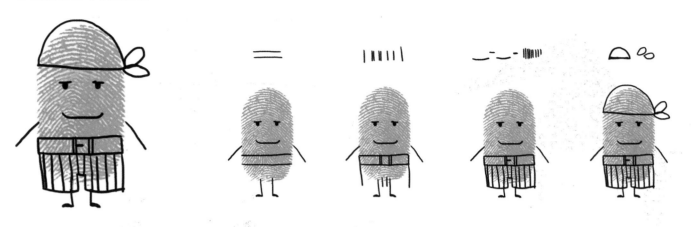

BANDIT

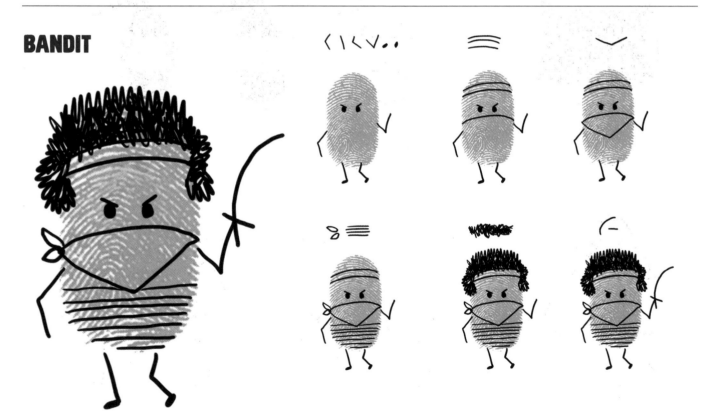

VIKING HELMET

 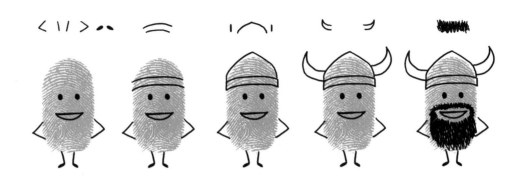

DRAGON SCALES

 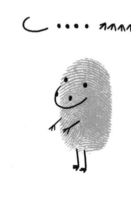 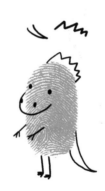 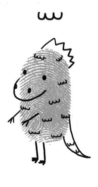

ALIEN

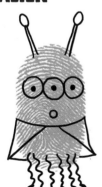 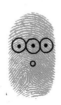 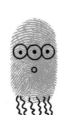 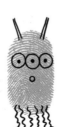 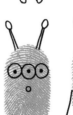 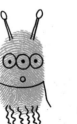

LIVELY MONSTERS

MONSTERS LOVE TO MOVE. LOOK HOW THEY LIMP, FLY, AND CRAWL!

LIMP

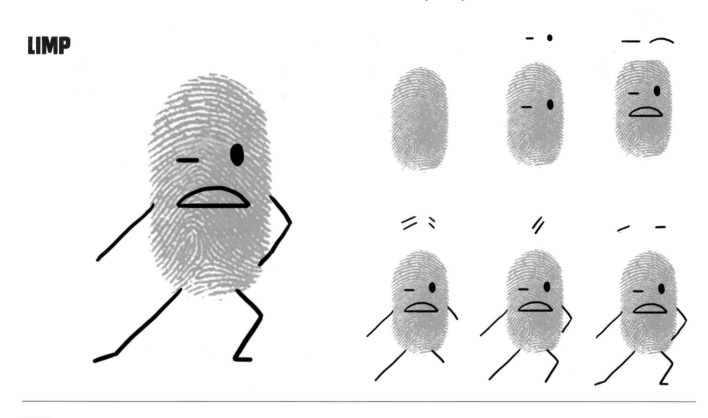

FLY

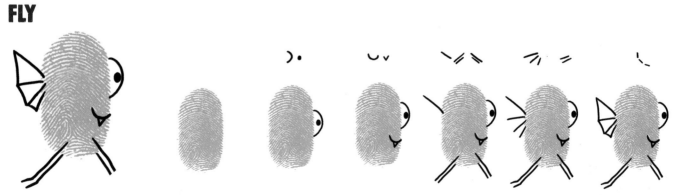

CRAWL

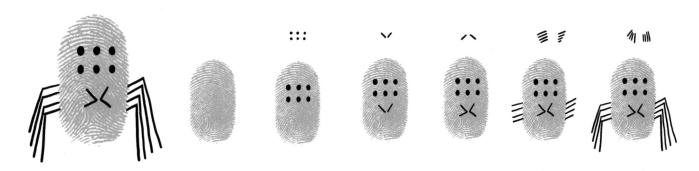

SPIT FIRE

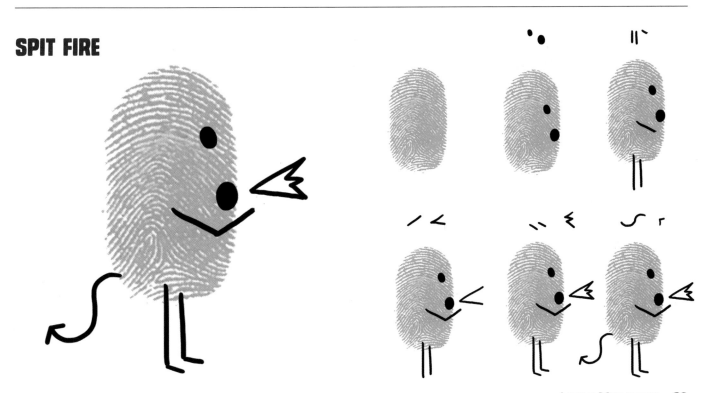

SCRATCH

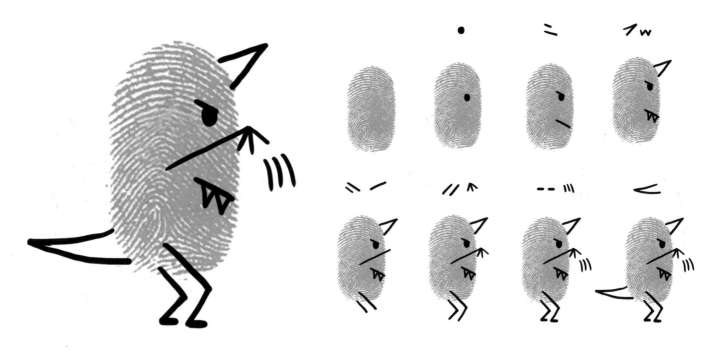

BARK

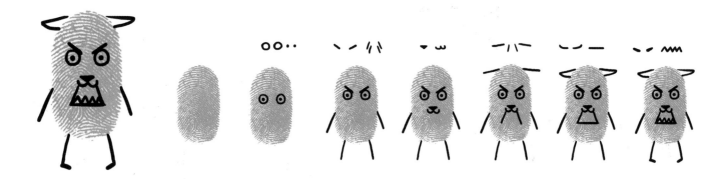

SWEEP

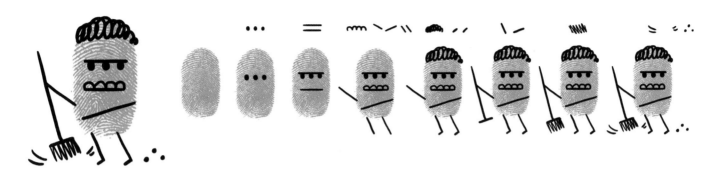

RIDE

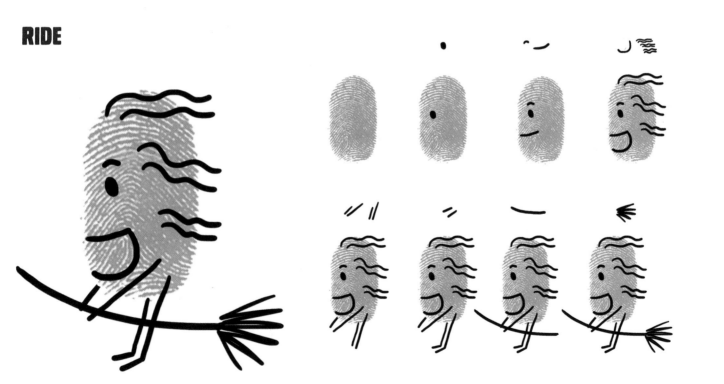

— THE ADVENTURE BEGINS! —

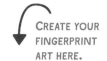CREATE YOUR
FINGERPRINT
ART HERE.

DRAGONS

TAKE A LOOK AT WHAT DRAGONS DO!

IN THE BEGINNING THEY ARE ONLY EGGS...

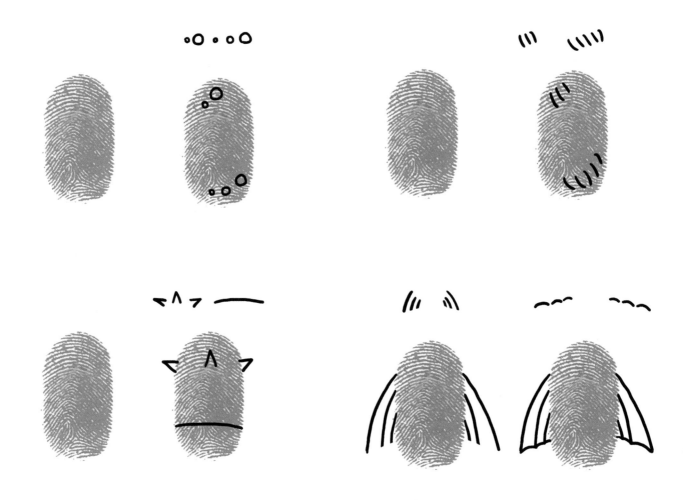

...BUT SOON WILL HATCH...

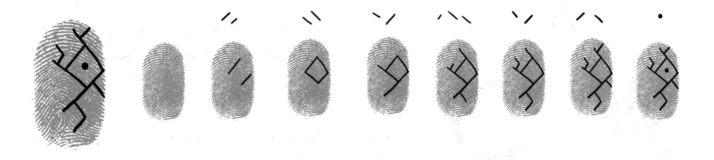

...A SMALL BABY DRAGON.

HE CAN FLY...

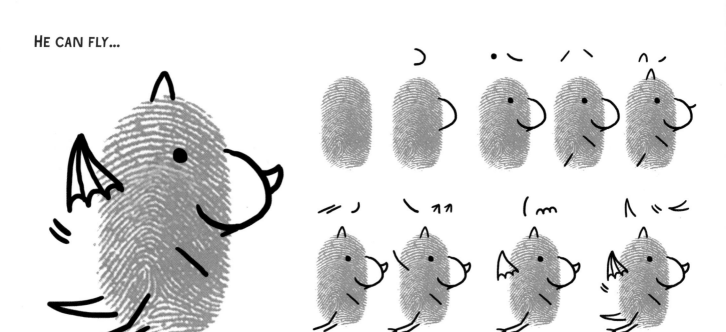

...AND HE CAN SPIT FIRE.

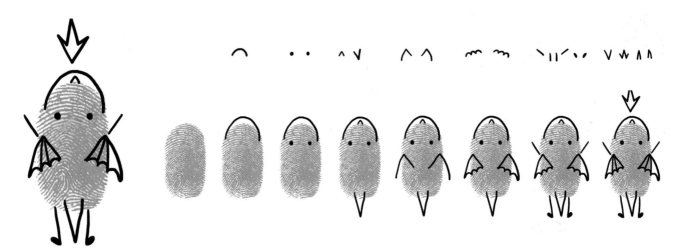

HE CAN SHOW HIS CLAWS...

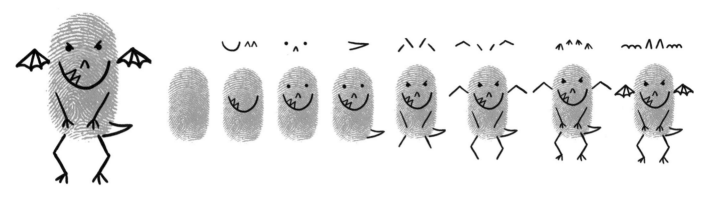

...AND READ TOGETHER WITH OTHER DRAGONS.

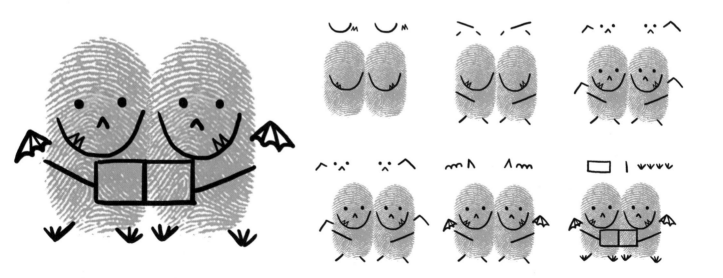

THERE ARE MANY DIFFERENT DRAGONS.

DRAGONS WITH POINTY SPIKES...

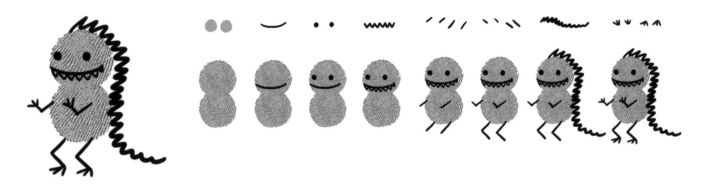

...HAPPY DRAGONS...

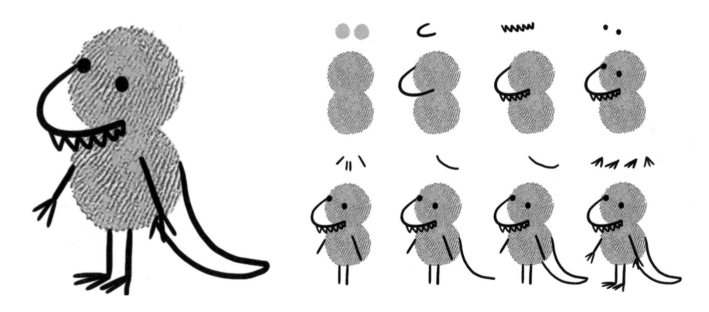

...DRAGONS WITH BIG WINGS...

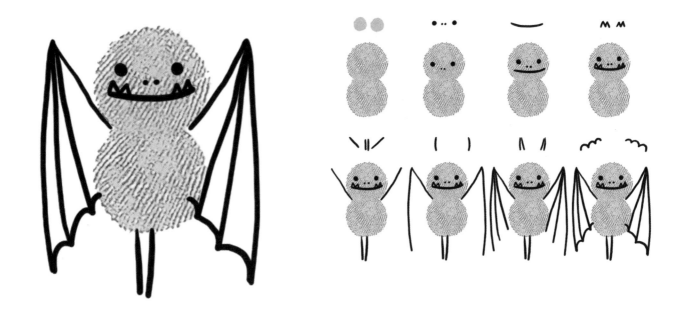

...OR DRAGONS WITH SHARP TEETH.

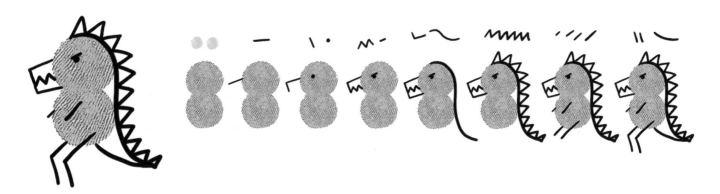

SOME DRAGONS ARE ALREADY OLD...

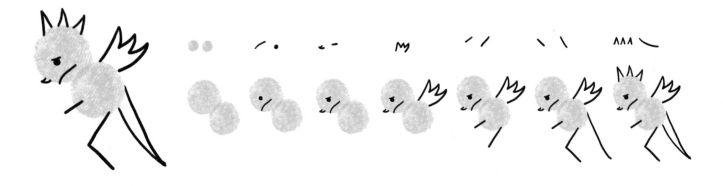

...OTHERS ARE STILL BABY DRAGONS.

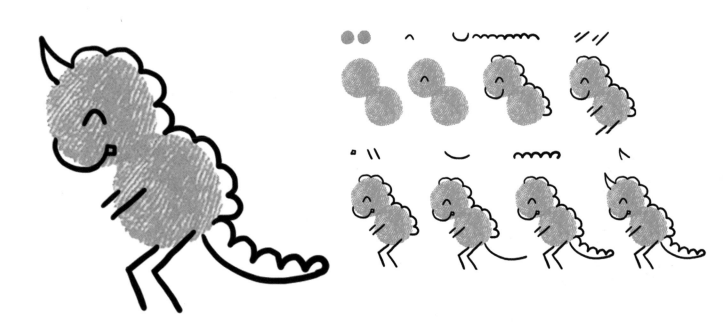

ALSO THERE ARE COZY DRAGONS...

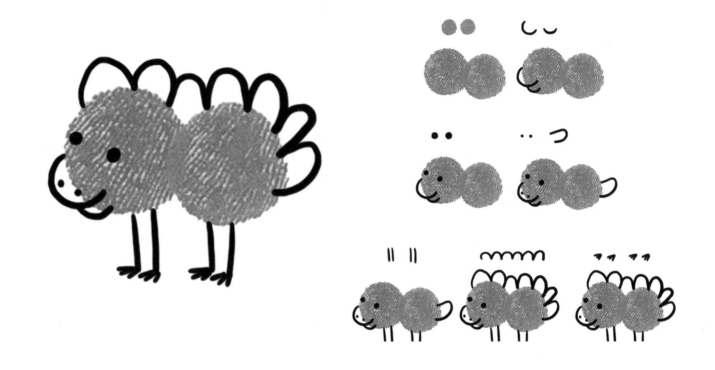

...AND OF COURSE THE ENORMOUS ONES!

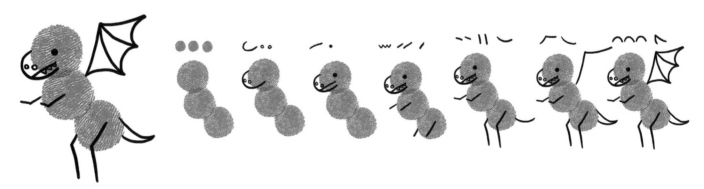

DRAGON MOM

THE DRAGON MOM IS BIG AND STRONG SO SHE CAN PROTECT HER YOUNG ONES.

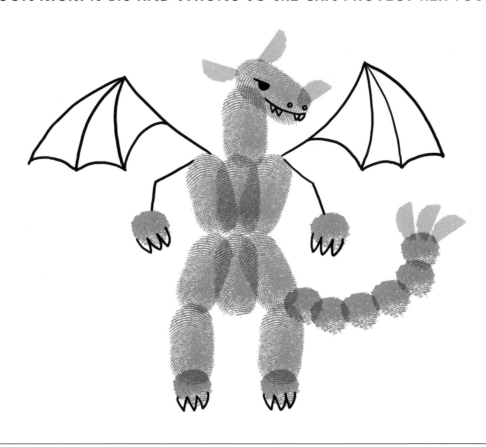

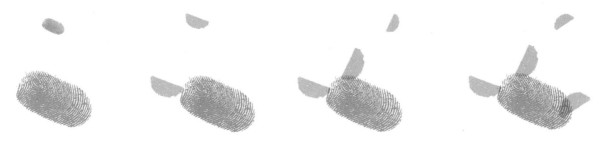

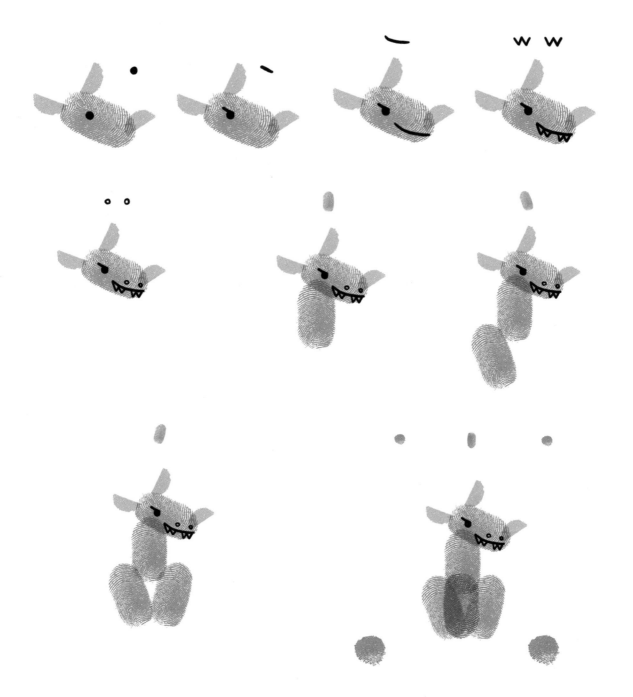

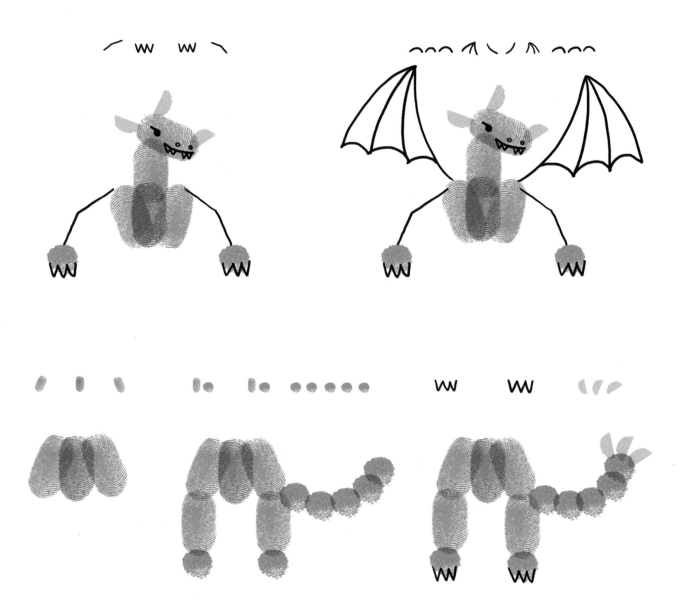

VARIATIONS

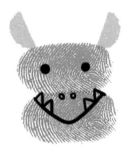
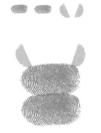
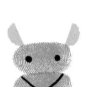
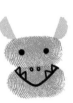

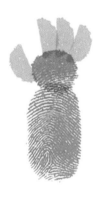
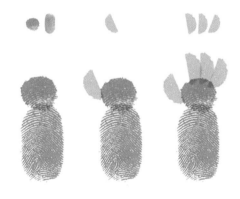

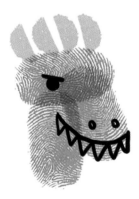
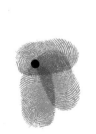
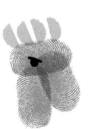
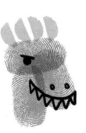

CREATE YOUR
FINGERPRINT
ART HERE.

— WHERE THE DRAGONS ARE. —

KNIGHTS

KNIGHTS ARE BRAVE AND STRONG!

THE KNIGHT WEARS A HELMET...

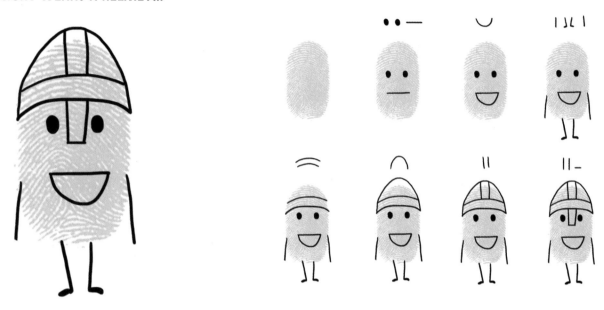

...THIS HELMET HAS A FACE PROTECTOR.

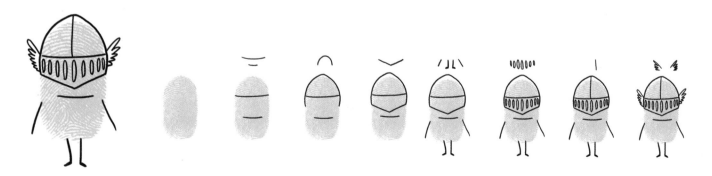

THIS HELMET COVERS THE KNIGHT'S WHOLE FACE.

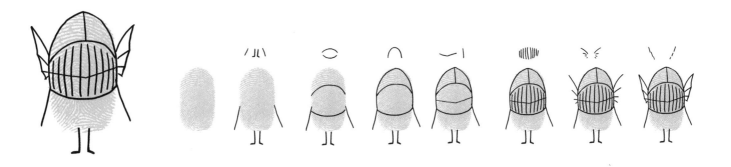

A MOHAWK IS ATTACHED TO THE TOP OF THIS HELMET.

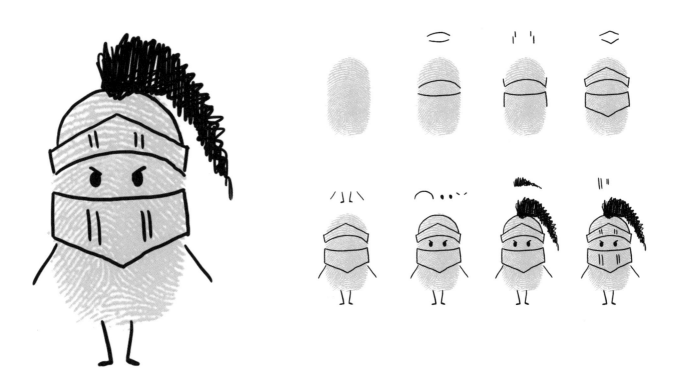

HERE ARE EVEN MORE KNIGHTS:

CRUSADER

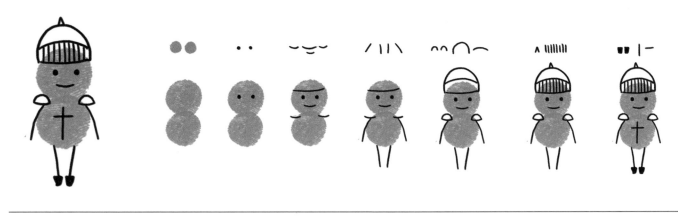

KNIGHT WITH SWORD

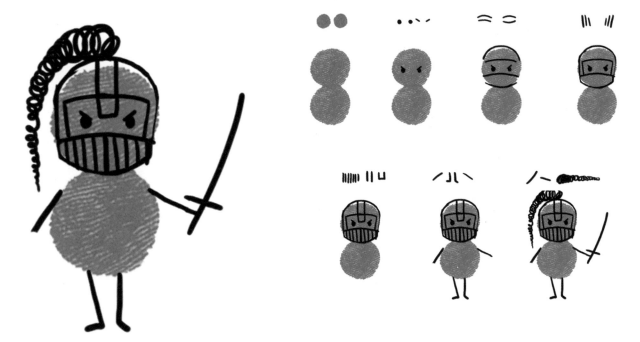

KNIGHT WITH SHIELD

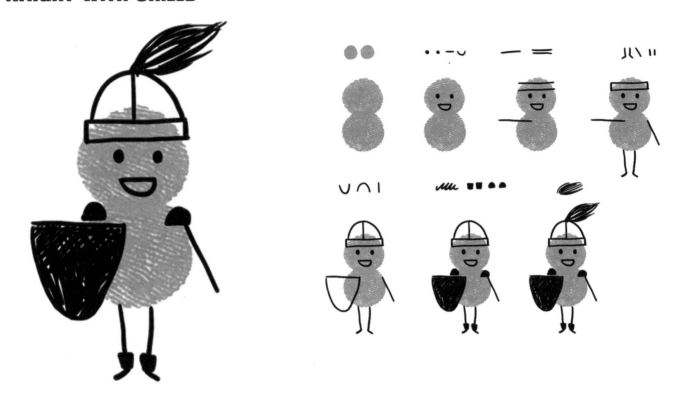

KNIGHT IN ENTIRE ARMOR

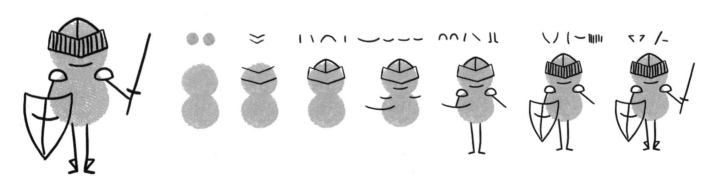

A KNIGHT IS NOT ALWAYS ALONE ON A JOURNEY;
INSTEAD, OFTEN A COMPANION IS ALONGSIDE.

HORSE

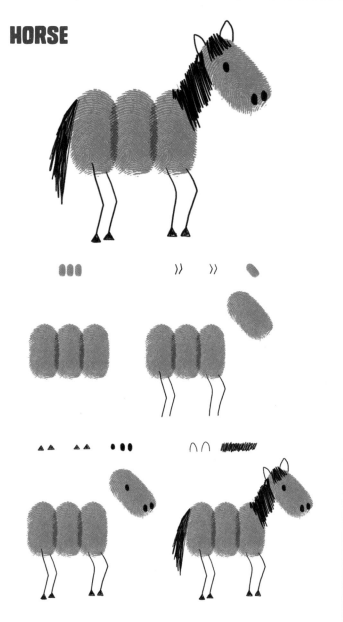

KNIGHT ON HORSE

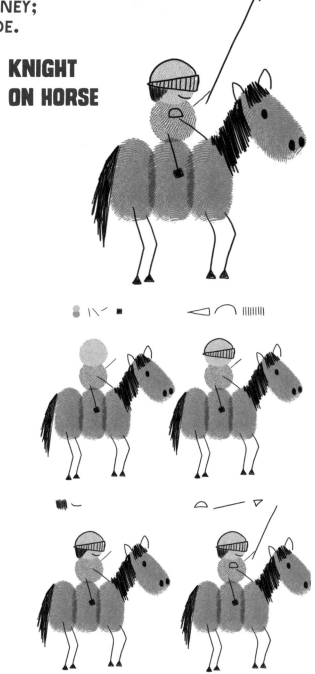

PRINCESS

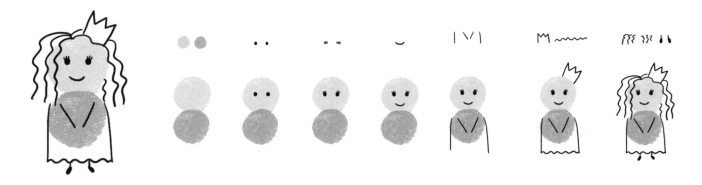

PRINCESS AND PRINCE

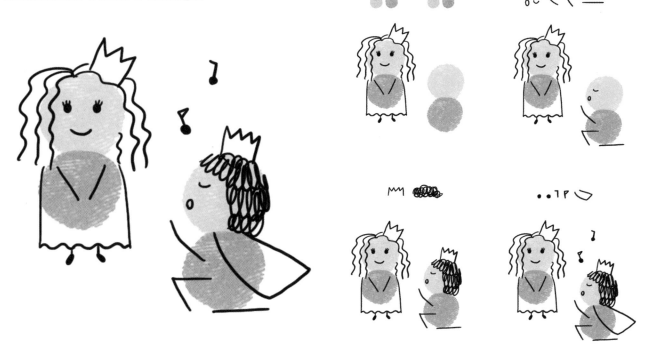

CREATE YOUR
FINGERPRINT
ART HERE.

GIANTS

GIANTS ARE VERY BIG. SOMETIMES THEY ARE DANGEROUS AND BREAK EVERYTHING.

GIANTS ARE GIGANTIC...

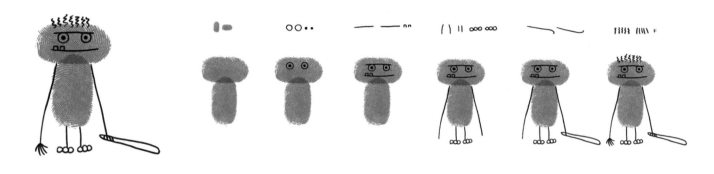

...THAT'S WHY THEY SLEEP OFTEN...

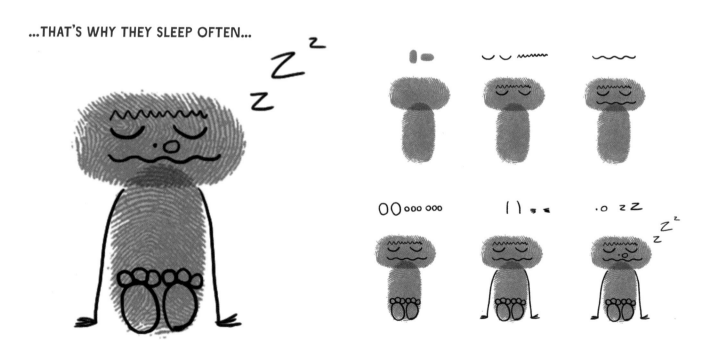

...AND EAT A LOT.

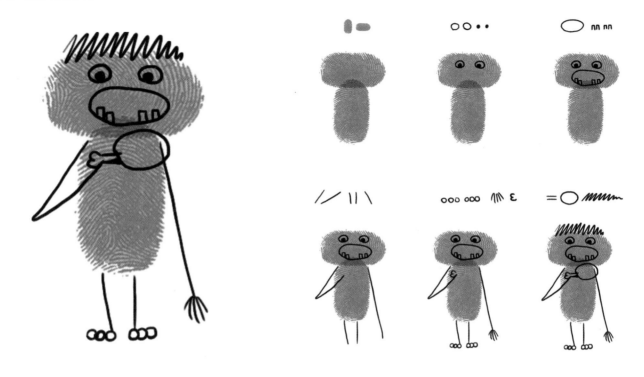

IN THEIR ENVIRONMENT ONE OFTEN FINDS:

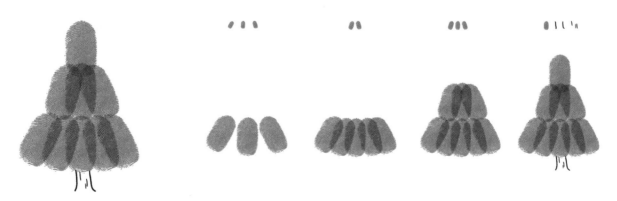

ROCKS

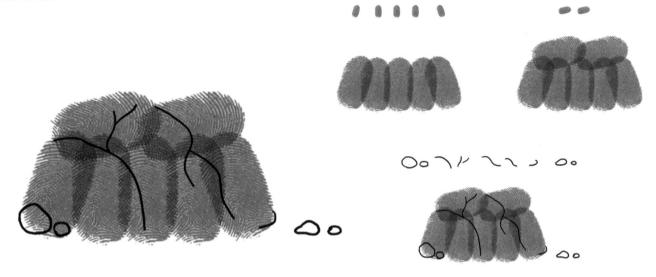

BIRDS

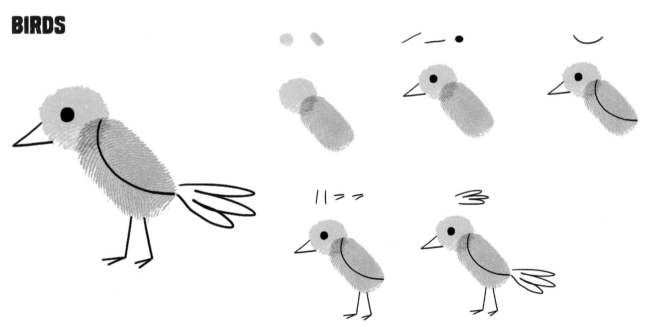

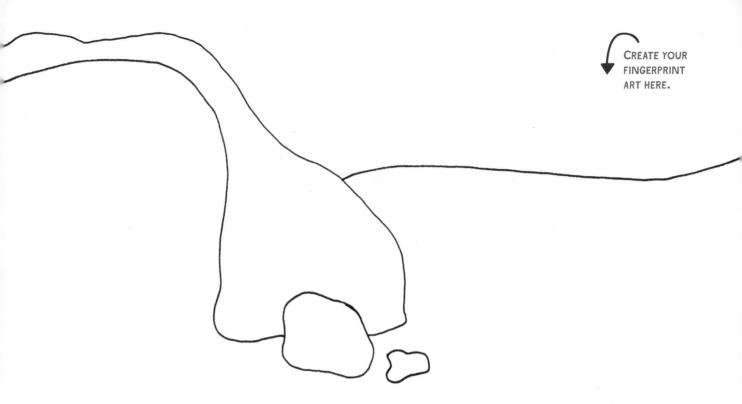

CREATE YOUR
FINGERPRINT
ART HERE.

— WHAT GIANTS DO. —

TROLLS

TROLLS ARE OFTEN TOGETHER WITH FAMILY AND FRIENDS.

THE TROLL MOM LIKES TO KNIT...

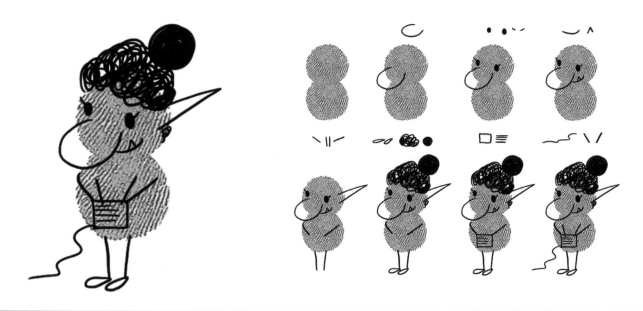

...AND THE TROLL DAD DIGS IN THE GARDEN.

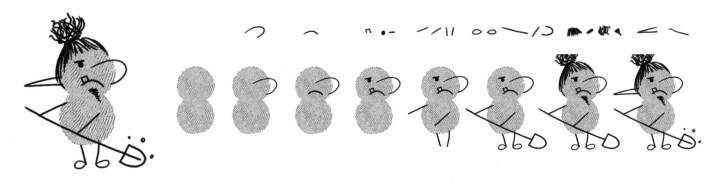

THE LITTLE TROLL BABY LOVES ITS PACIFIER...

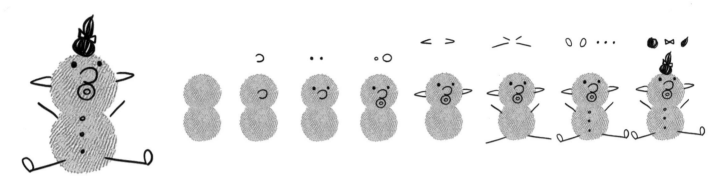

...AND THE TROLL CHILD PLAYS WITH THE RATTLE.

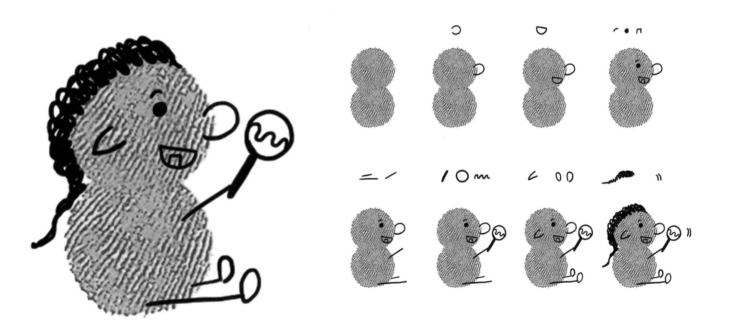

AMONG THE WORLD OF TROLLS ARE ALSO ANIMALS:

BUG

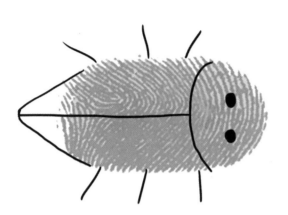

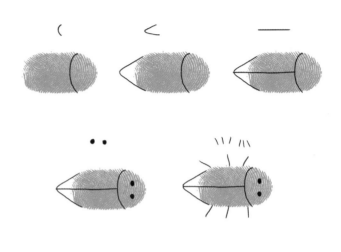

BEE

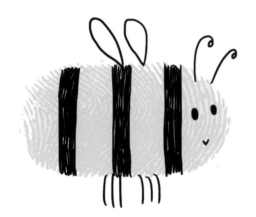

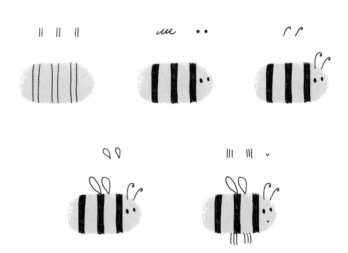

BEETLE

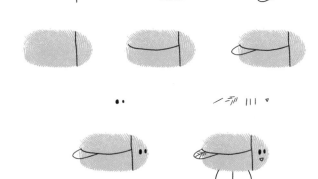

CATERPILLAR

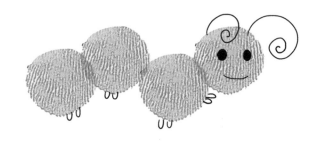

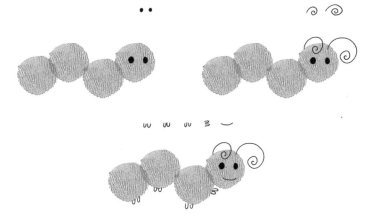

LADYBUG

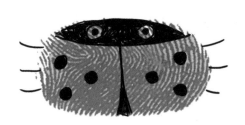

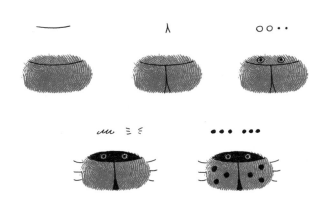

GIANT ON A ROCK

SOMETIMES GIANTS HAVE TO TAKE A BREAK.

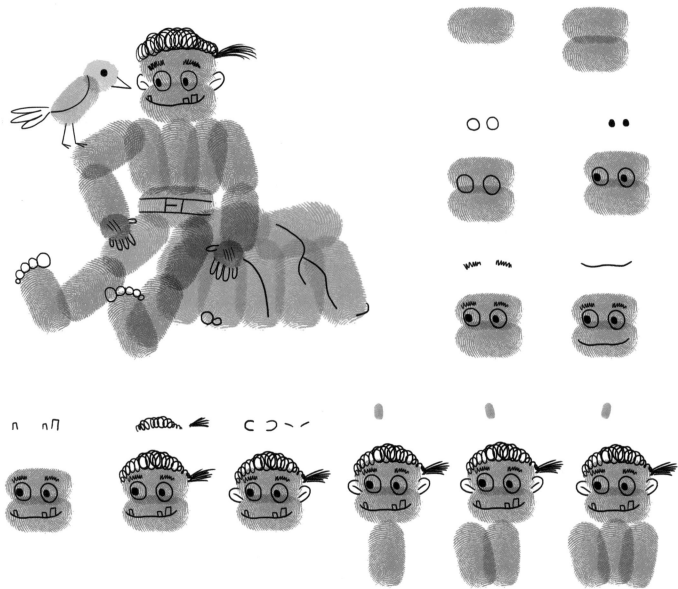

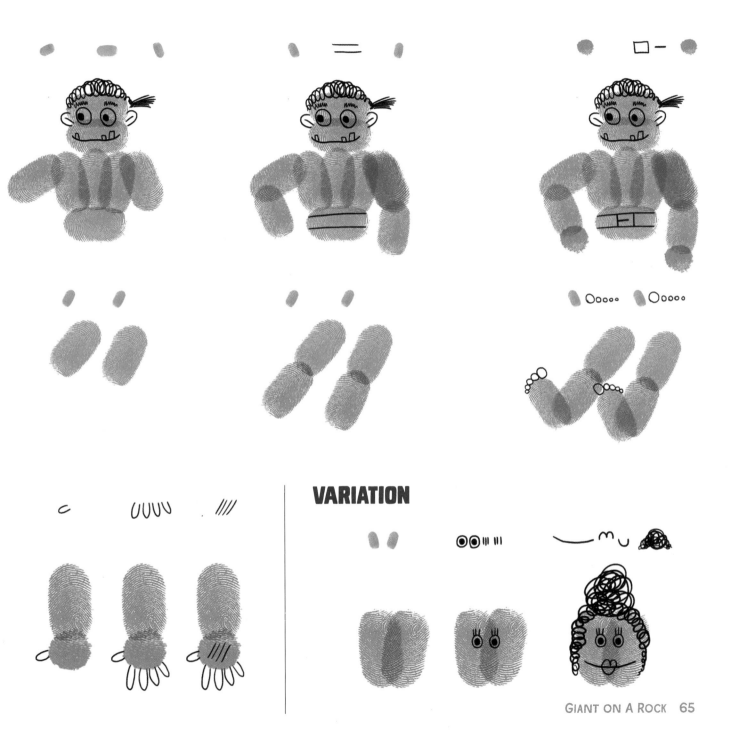

VARIATION

LOYAL COMPANIONS

MONSTERS AND HEROES OFTEN HAVE LOYAL COMPANIONS WITH THEM.
CAN YOU GUESS WHICH COMPANION BELONGS TO WHOM?

BAT

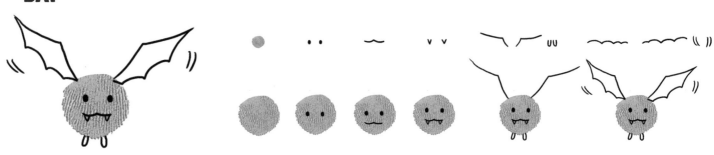

RAT

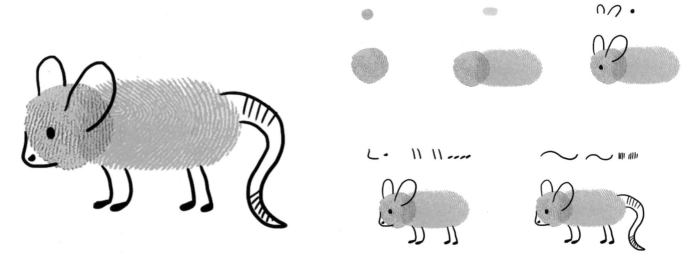

PARROT

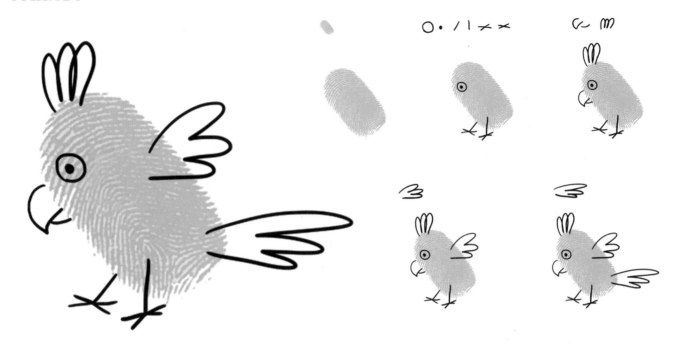

CAT

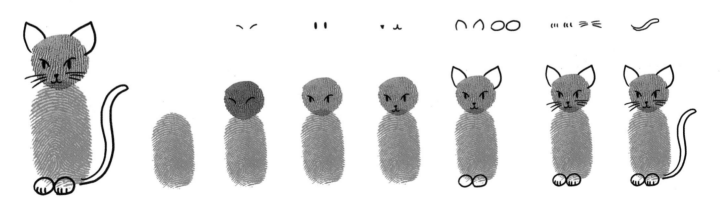

OWL

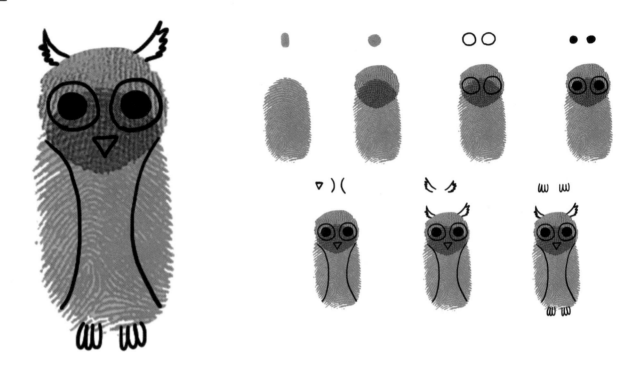

VULTURE

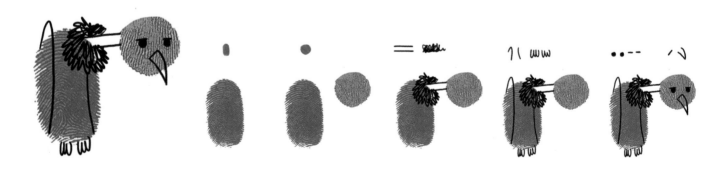

RATTLESNAKE

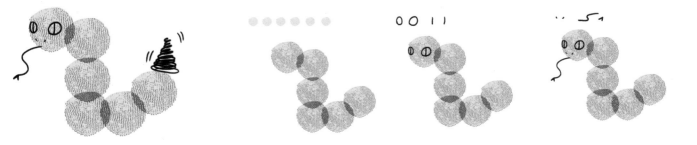

DOG

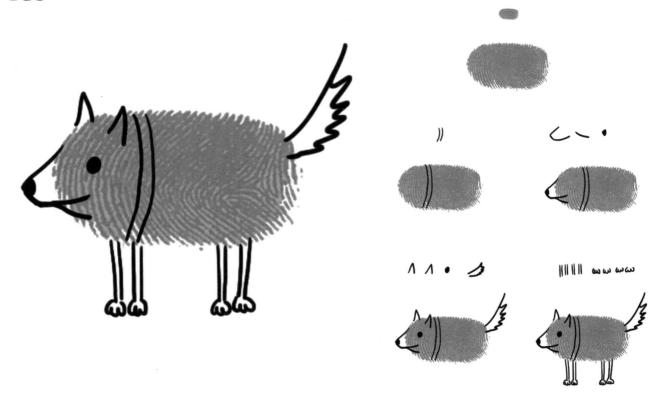

CREATE YOUR
FINGERPRINT
ART HERE.

— OUT FOR THE DAY WITH MY LOYAL COMPANIONS —

SPIDER

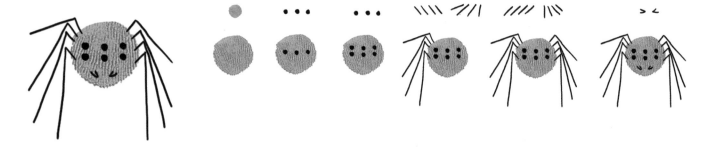

RABBIT

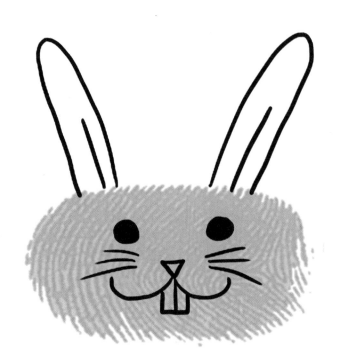

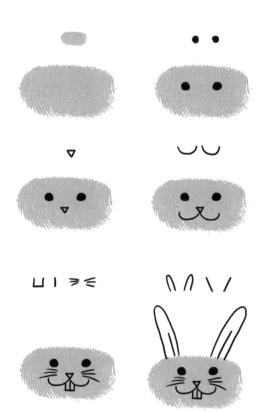

RACCOON

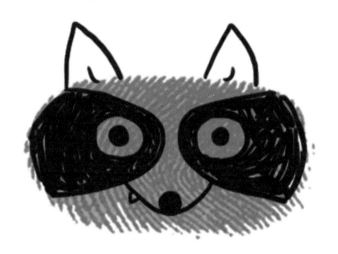

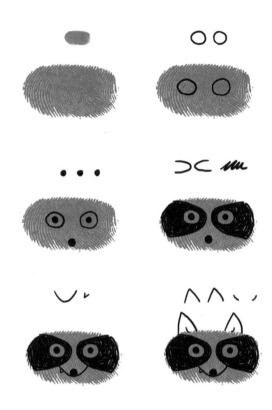

BEAR

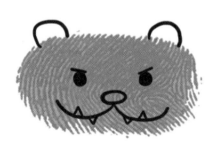

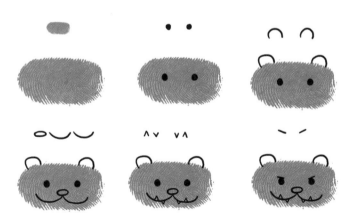

MOUSE

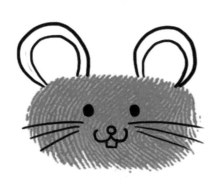

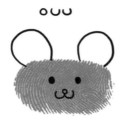

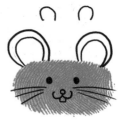

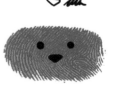

FOX

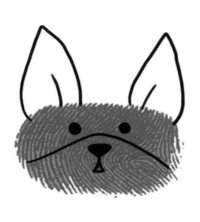

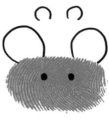

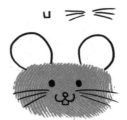

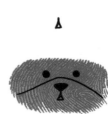

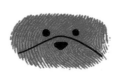

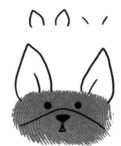

CREATE YOUR
FINGERPRINT
ART HERE.

— FROLICKING IN THE FOREST —

ROBOT

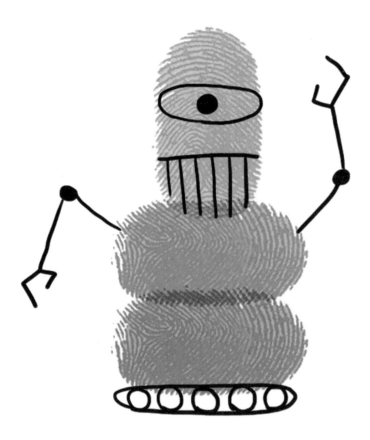

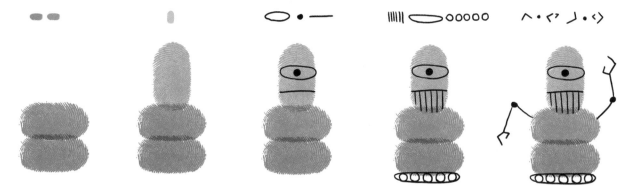

SKELETON

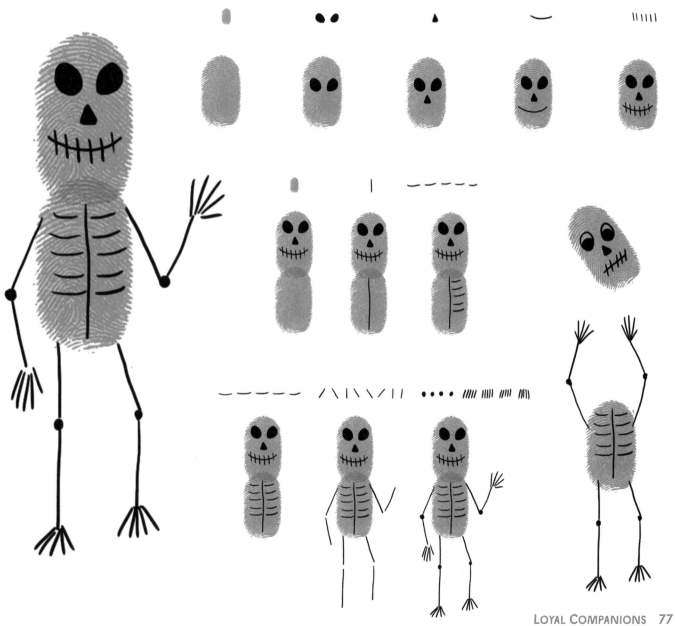

EVERYTHING MAGICAL

HOCUS POCUS AND THREE BLACK CATS!
ARE YOU INTERESTED IN DOING SOME MAGIC?

WIZARD'S FACE

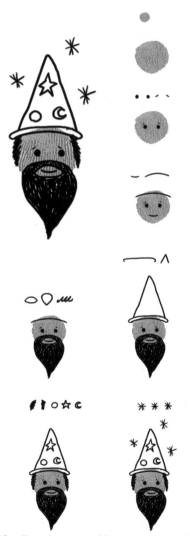

WIZARD WITH MAGIC WAND

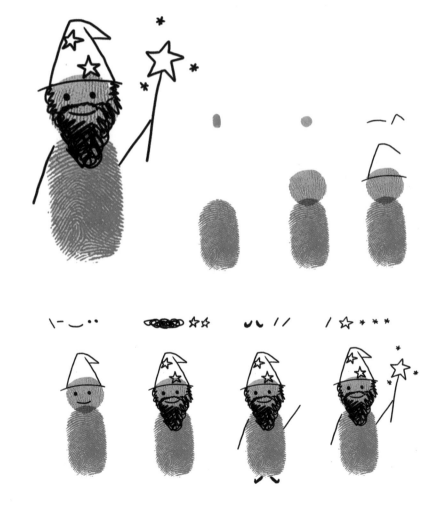

WIZARD BETWEEN BOOKS

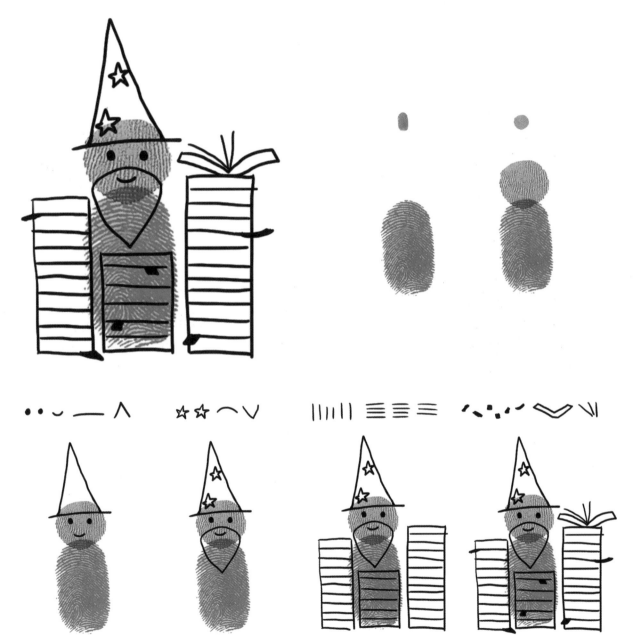

THE FOLLOWING ARE THINGS A WIZARD NEEDS TO DO MAGIC:

BUNNY IN HAT

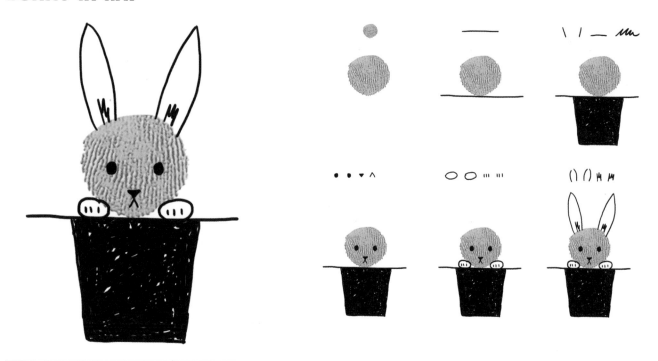

CAULDRON

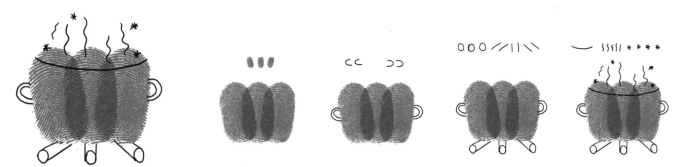

WISE OWL

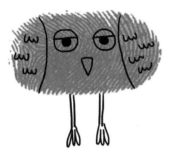

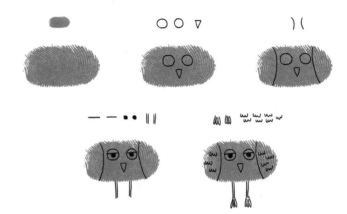

MAGIC WAND

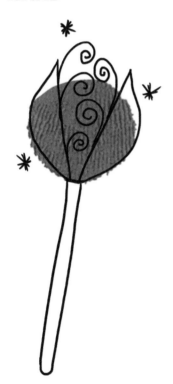

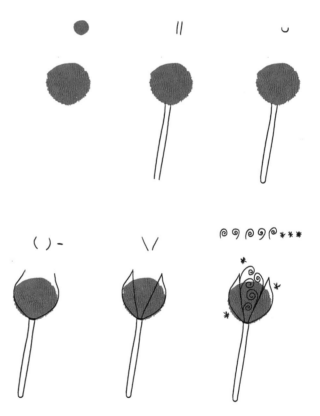

VARIOUS PLAYING CARDS

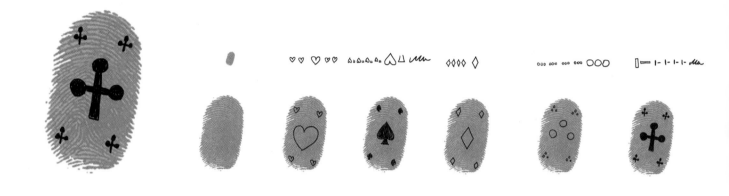

WITCH'S BROOM

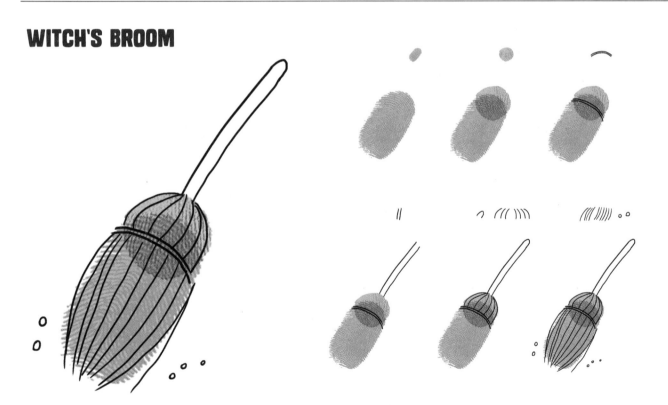

WALKING STICK

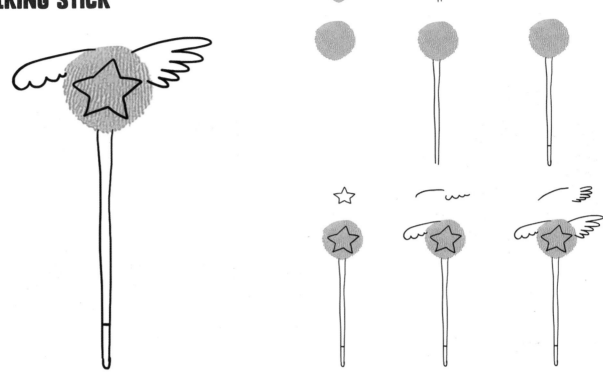

BOOK WITH SPELLS

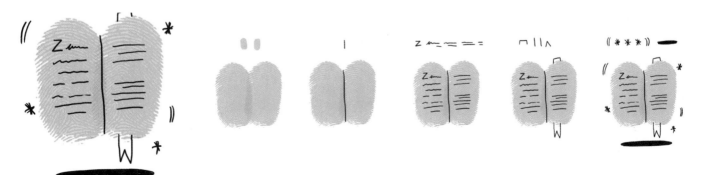

WIZARD'S LOYAL ASSISTANTS:

THE GRANDDAUGHTER HELPS WITH HIS PAPERWORK.

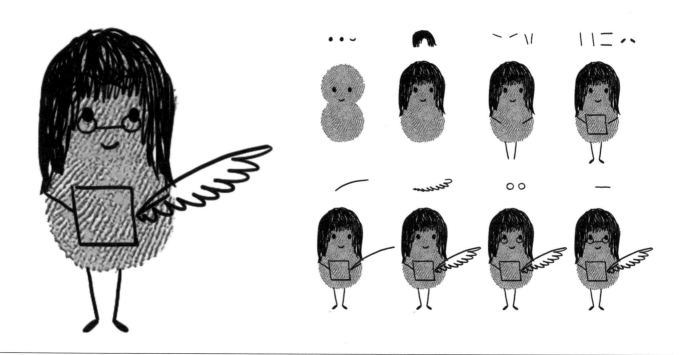

SORCERER'S APPRENTICE PRACTICES SPELLS.

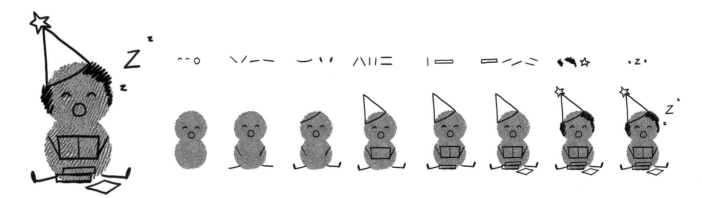

THE LOYAL CAT DOESN'T LEAVE HIS SIDE.

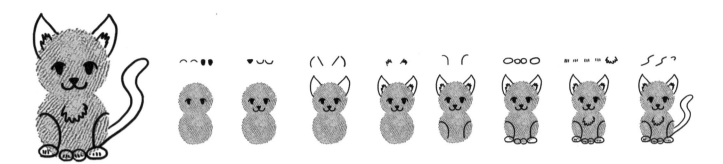

HIS FRIEND, THE ALCHEMIST, BREWS POTIONS.

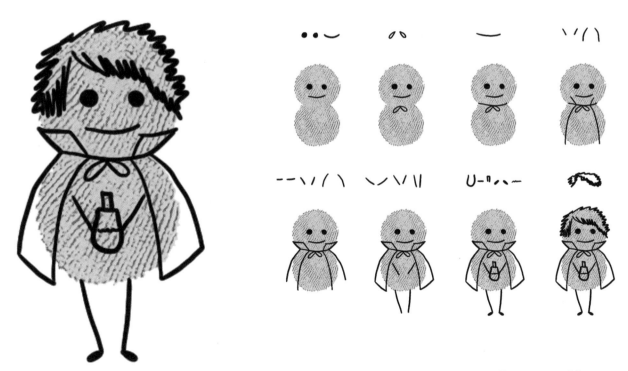

— THE LIBRARY OF MAGIC —

CREATE YOUR
FINGERPRINT
ART HERE.

PIRATE GANG

PIRATES ARE ALMOST ALWAYS AT SEA.

THE PIRATE CAPTAIN WEARS A HAT.

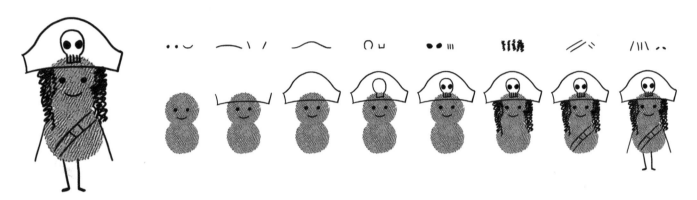

ONE-ARMED PIRATE

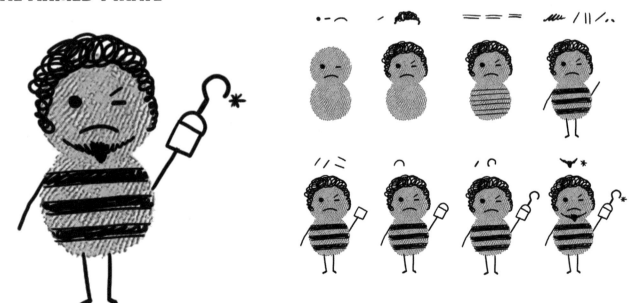

PIRATE WITH EYE PATCH

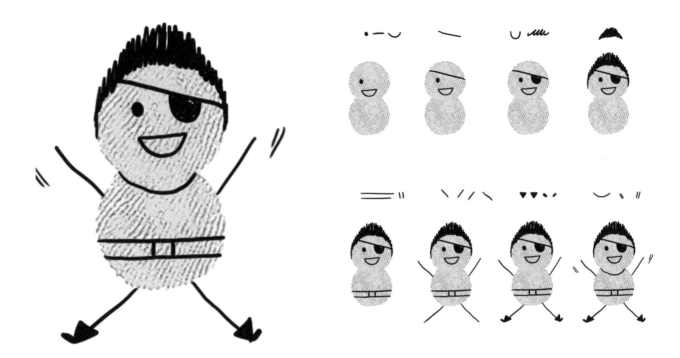

PIRATE WITH PEG LEG

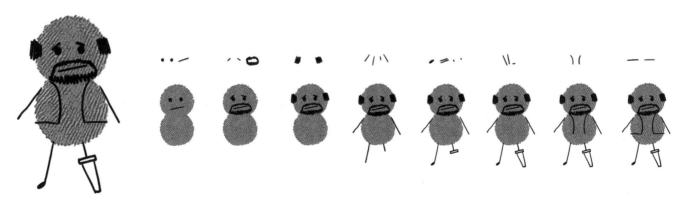

PIRATE AT STEERING WHEEL

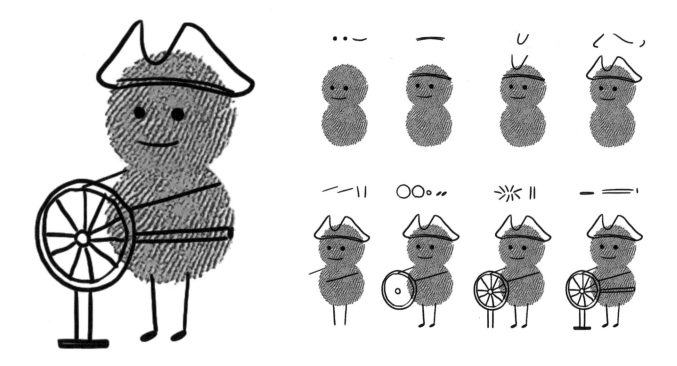

PIRATE WITH A TELESCOPE

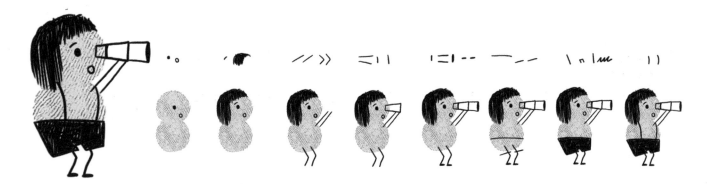

PIRATE WITH SABER

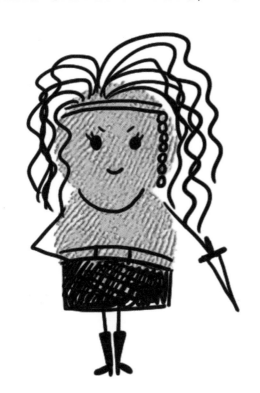

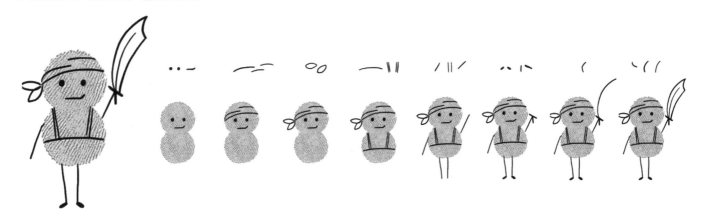

GIRLS CAN BE PIRATES, TOO.

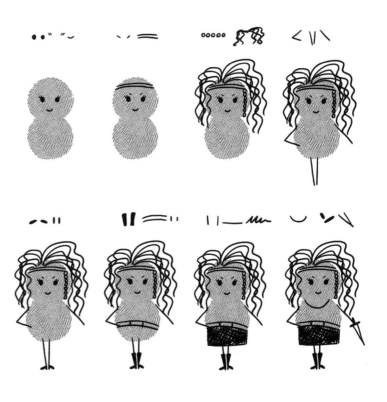

ON THEIR JOURNEYS, PIRATES EXPERIENCE EXCITING THINGS.

PIRATES FIND A TREASURE.

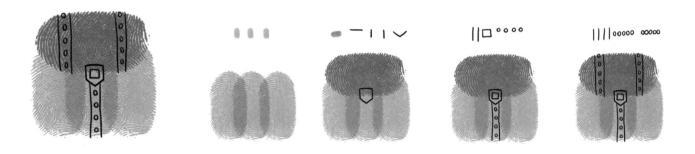

THEY NEED A TREASURE MAP FOR THAT...

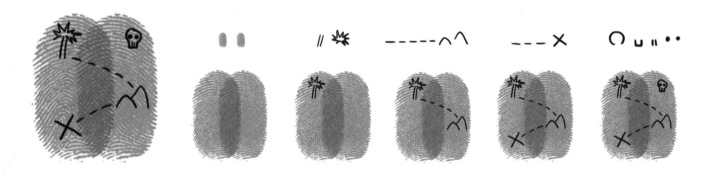

SOMETIMES A PIRATE LOSES AN EYE...

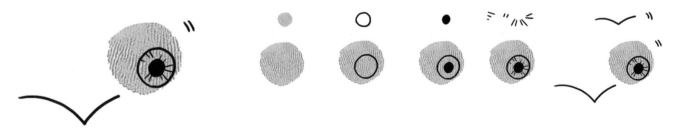

THEIR FLAG SHOWS A SKULL.

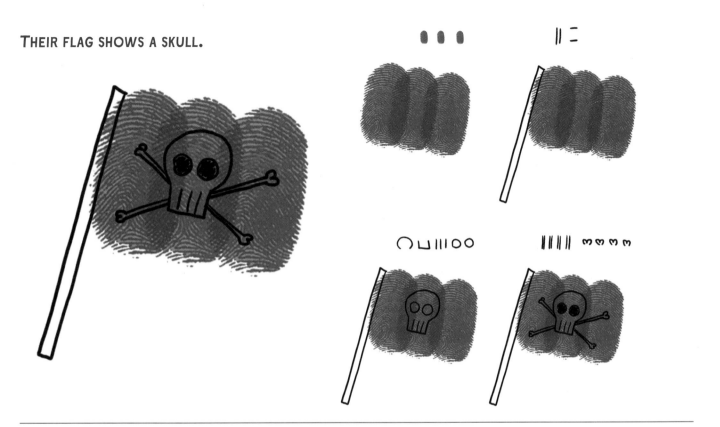

...AND THEY CAN'T TRAVEL WITHOUT A COMPASS.

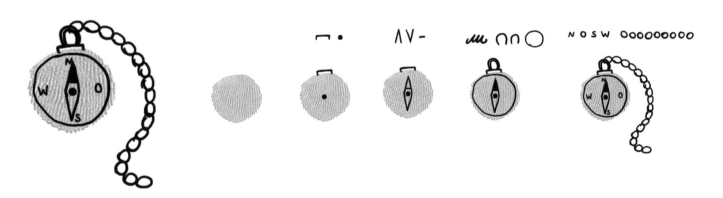

ON THE WATER, PIRATES DISCOVER MANY ANIMALS SUCH AS SQUIDS...

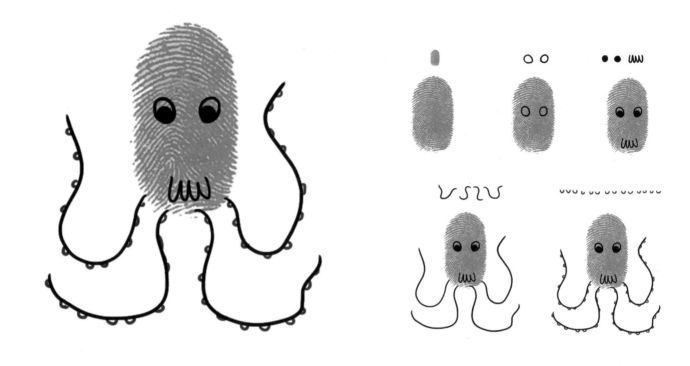

...OR DANGEROUS SHARKS.

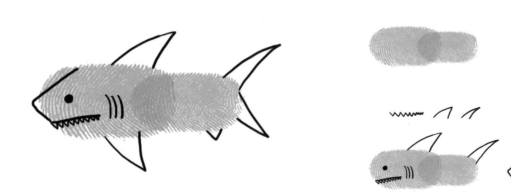

SOMETIMES THEY SEE VERY OLD TURTLES, TOO...

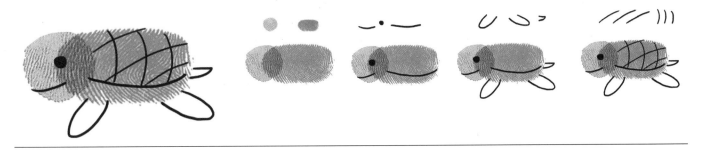

...OR PUFFER FISH.

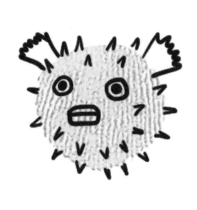

THEY SEE COLORFUL FISH, TOO.

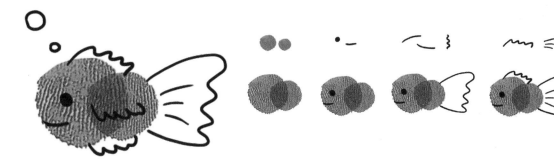

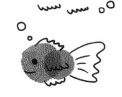

PIRATE SHIP

LET YOUR PIRATE GANG SAIL
THEIR SHIP AND DISCOVER THE
WORLD.

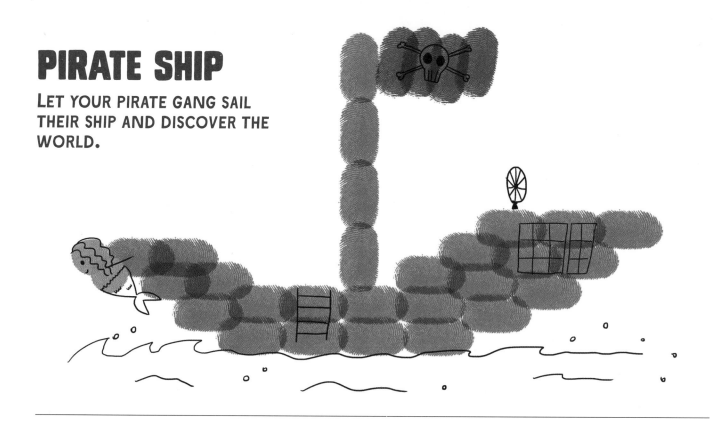

FIGUREHEAD

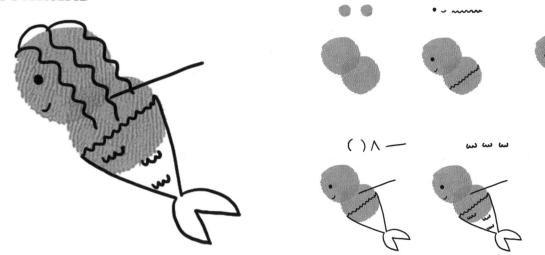

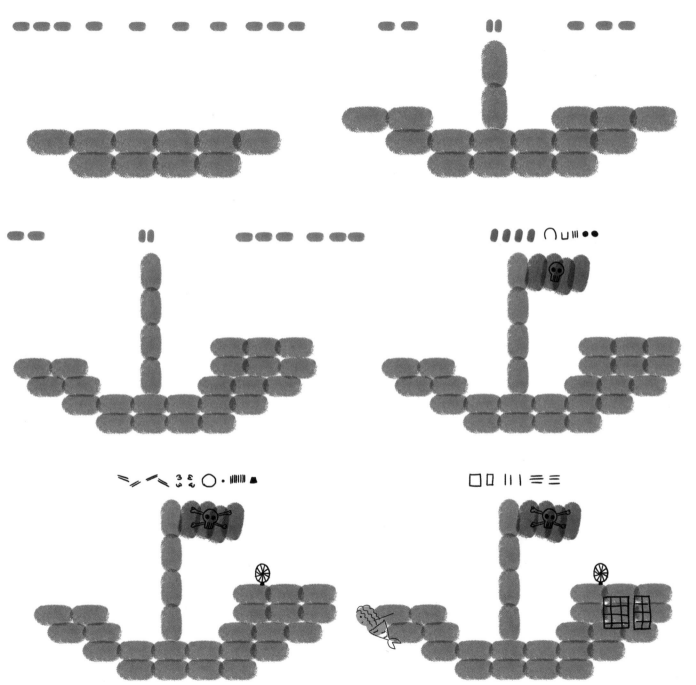

— VOYAGE OF THE PIRATE GANG —

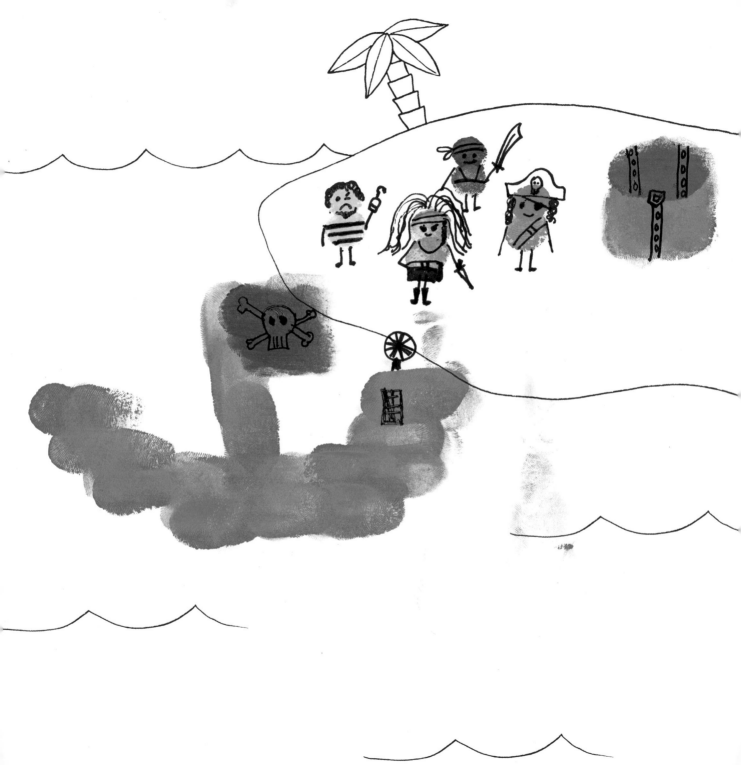

IN SPACE

THERE IS MUCH TO SEE IN SPACE!

OLD ROBOT

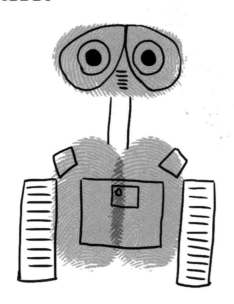

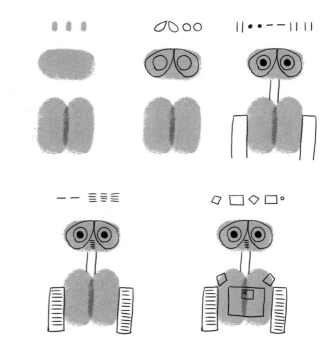

MODERN ROBOT

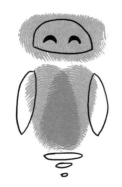

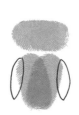
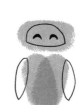
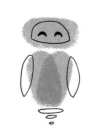

CONFUSED ROBOT

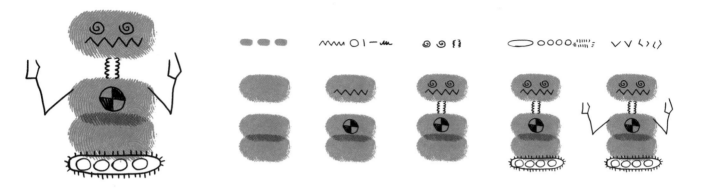

ALIEN WITH THREE EYES

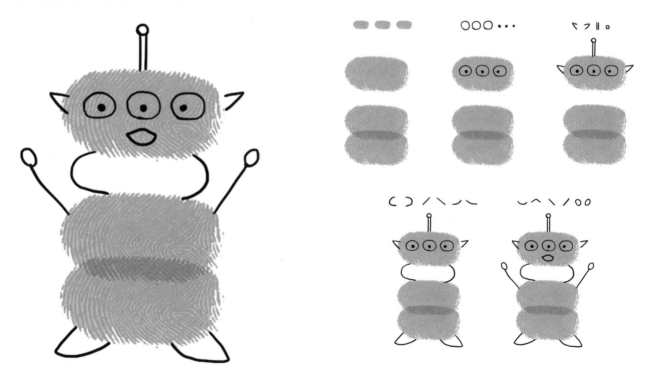

ALIEN WITH LONG ANTENNAS

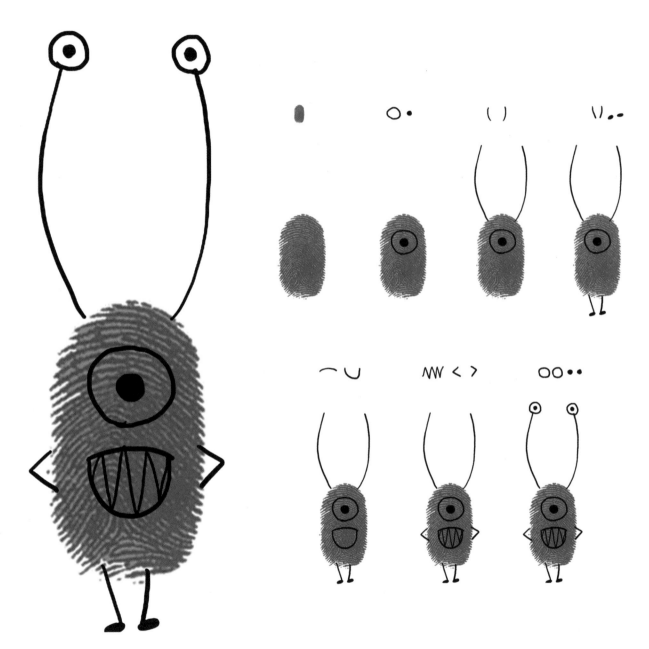

Discover zero gravity and other planets.

SATELLITE

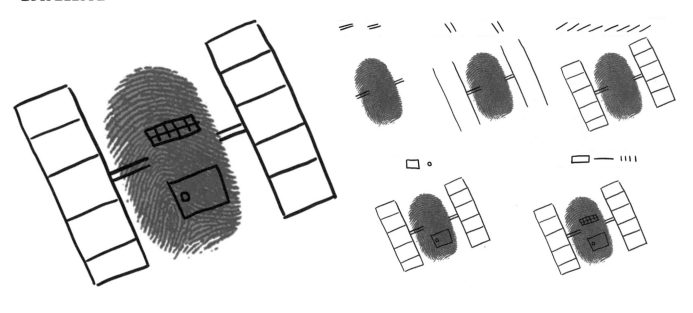

ASTRONAUT

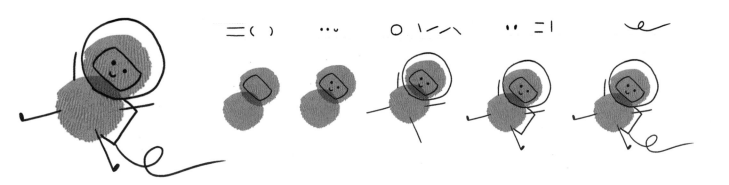

MARS MAN

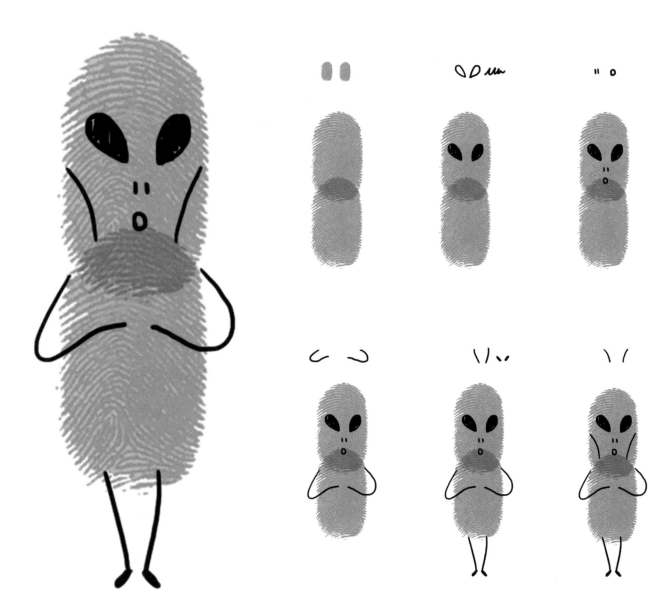

ROCKET

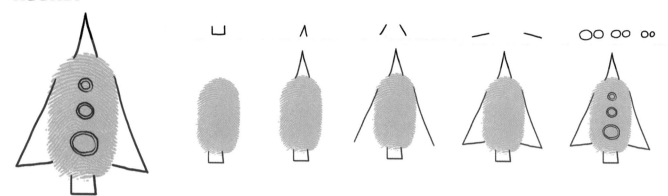

ROCKET WITH FIRE

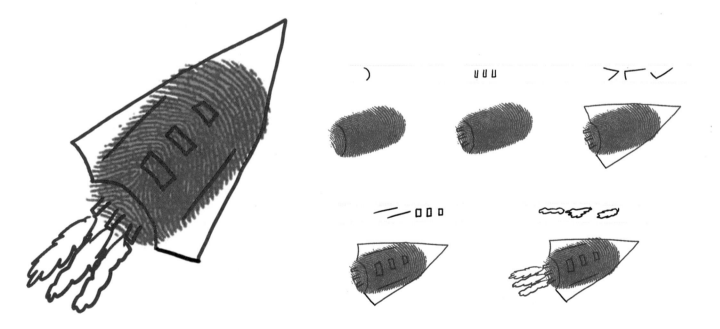

— FAR OUT... —

CREATE YOUR
FINGERPRINT
ART HERE.

UFO

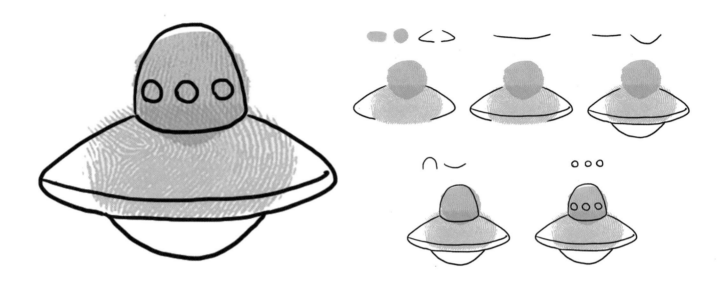

UFO WITH SPOTLIGHT

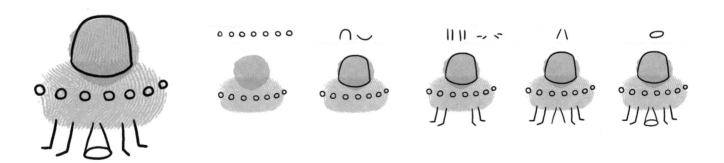

COMET

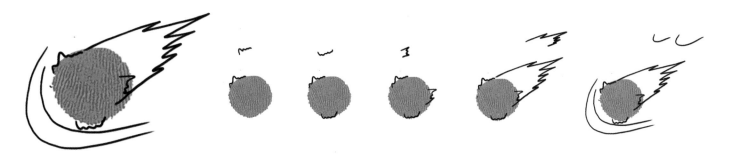

MOON

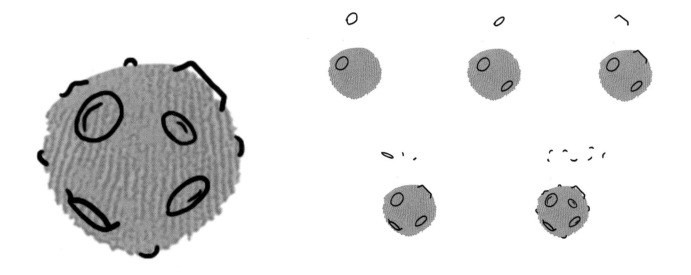

SUN

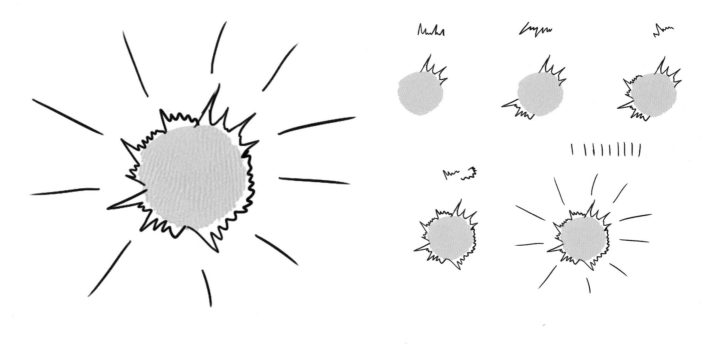

SATURN

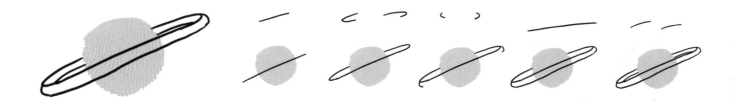

CREATE YOUR
FINGERPRINT
ART HERE.

— ...WAY OUT —

ASTRONAUT

ASTRONAUTS TRAVEL THROUGH THE UNIVERSE.

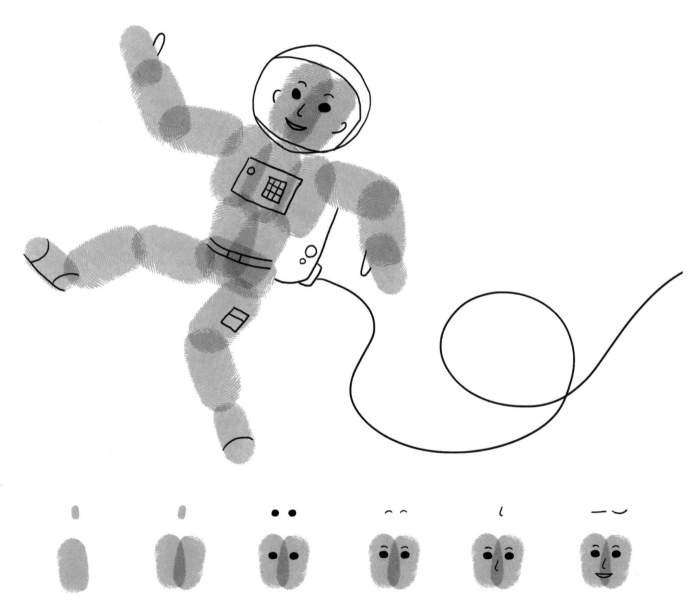

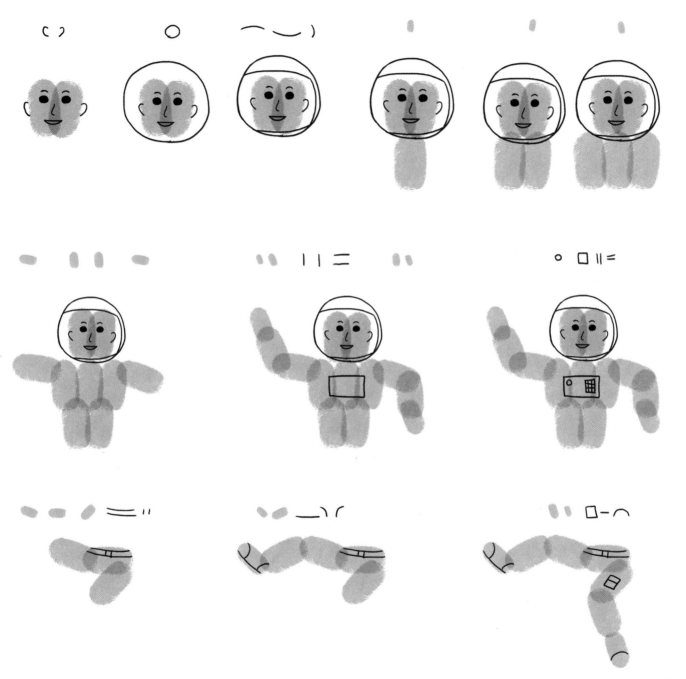

THE WILD WEST

THERE'S A LOT GOING ON IN THE WILD WEST! LOOK WHO IS BUSTLING ABOUT.

NATIVE AMERICANS OFTEN WEAR FEATHERS IN THEIR HAIR...

...AND RIDE ON WILD HORSES.

(SEE P.52)

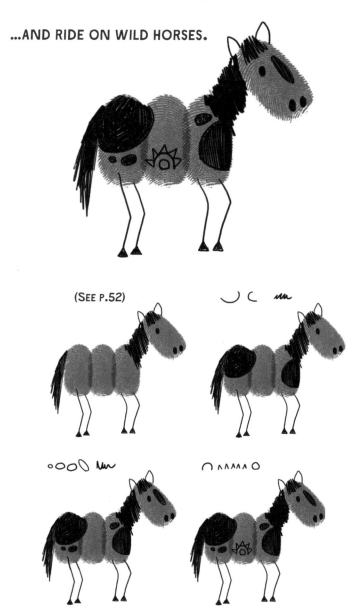

THE NATIVE AMERICAN MOM HAS HER BABY WARMLY WRAPPED.

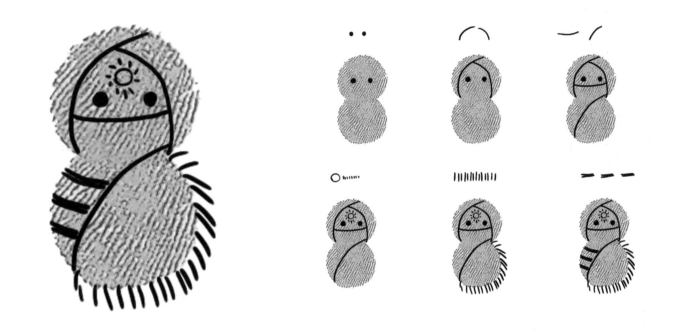

NATIVE AMERICANS LIKE TO SIT AROUND A BONFIRE...

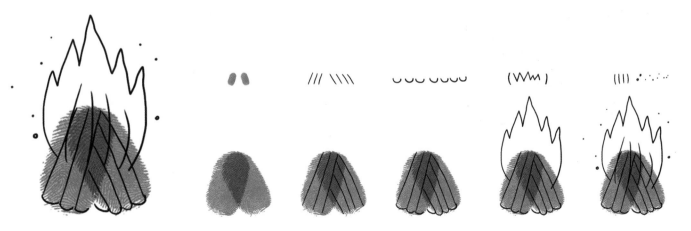

...AND LIVE IN TEPEES. THOSE ARE TENTS.

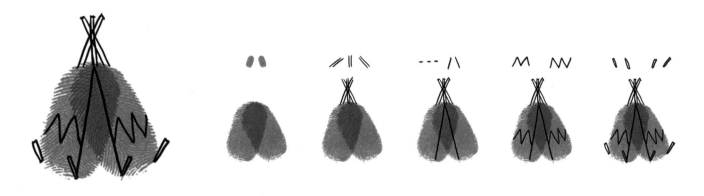

THEY HUNT THEIR FOOD USING BOWS AND ARROWS.

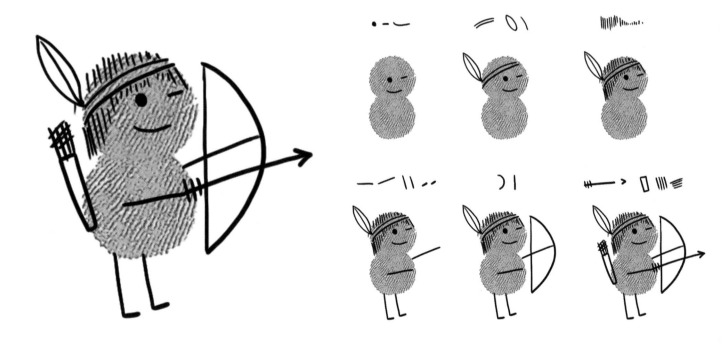

OR WITH A SPEAR.

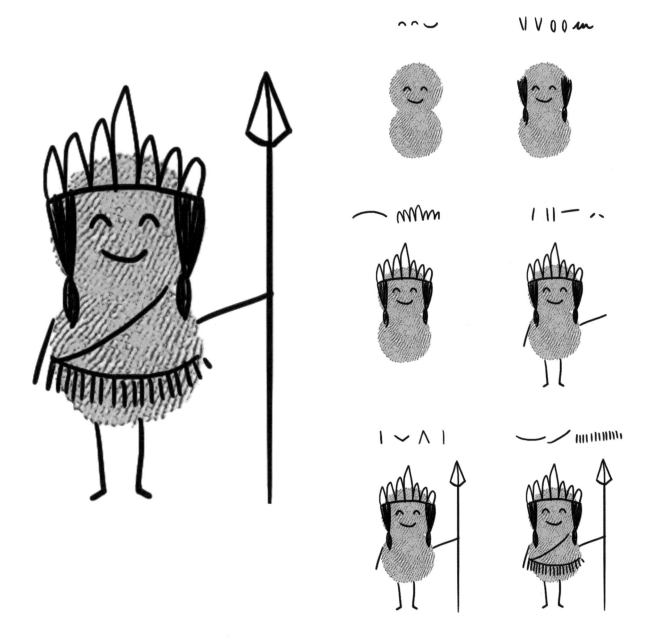

COWBOYS

WHAT WOULD THE WILD WEST BE WITHOUT COWBOYS?

COWBOYS WEAR HATS MOSTLY...

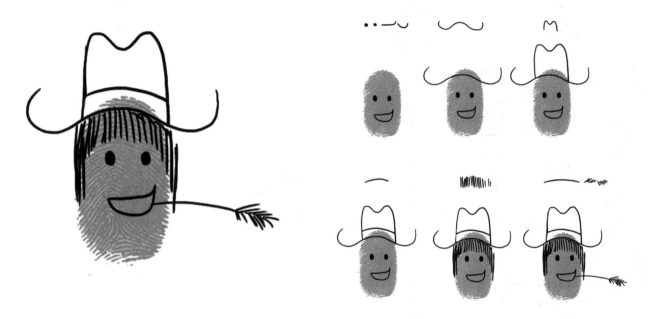

...AND LIKE BANDANAS.

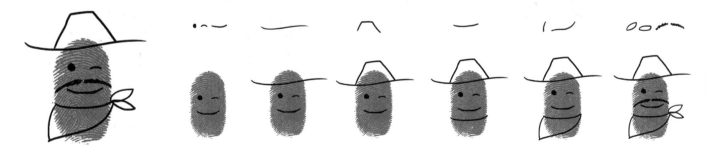

SOME COWBOYS ALSO HAVE A SHERIFF STAR.

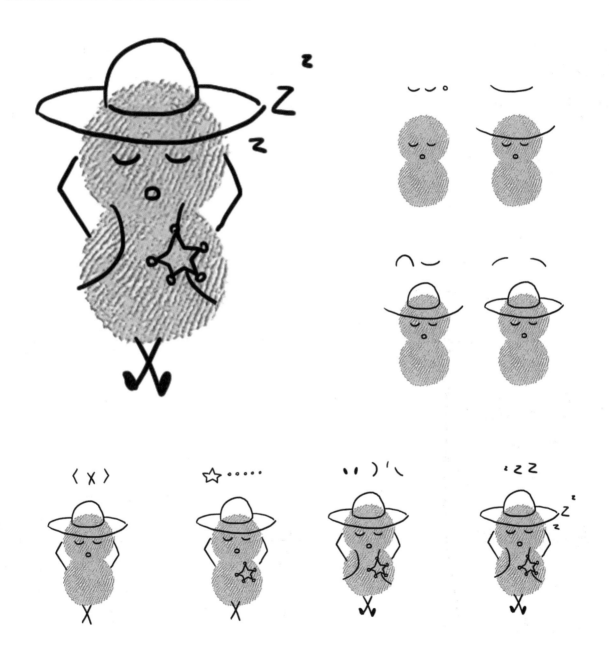

THEY OFTEN HAVE PISTOLS WITH THEM.

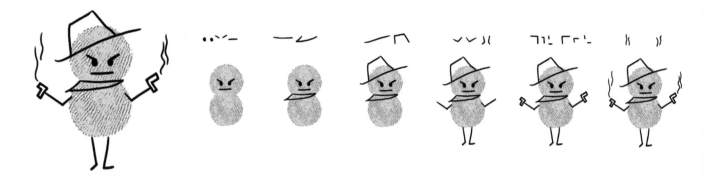

COWBOYS NEVER LEAVE THE HOUSE WITHOUT THEIR LASSO.

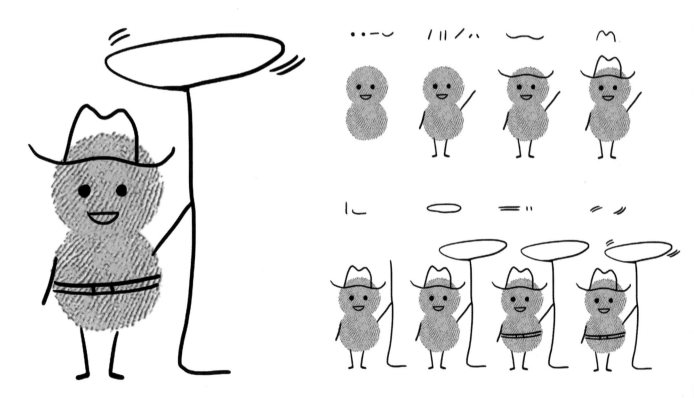

ON THEIR FEET, COWBOYS LIKE TO WEAR COWBOY BOOTS.

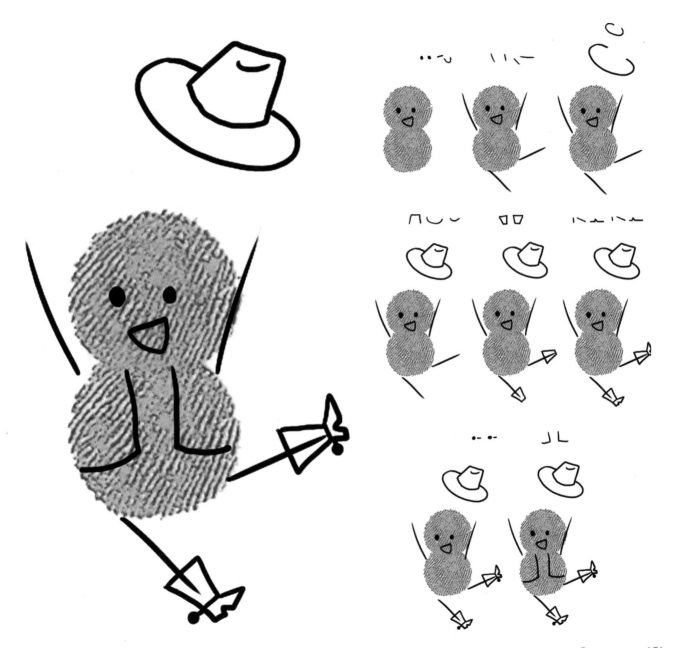

COWBOYS ARE ALWAYS READY FOR A GAME OF CARDS.

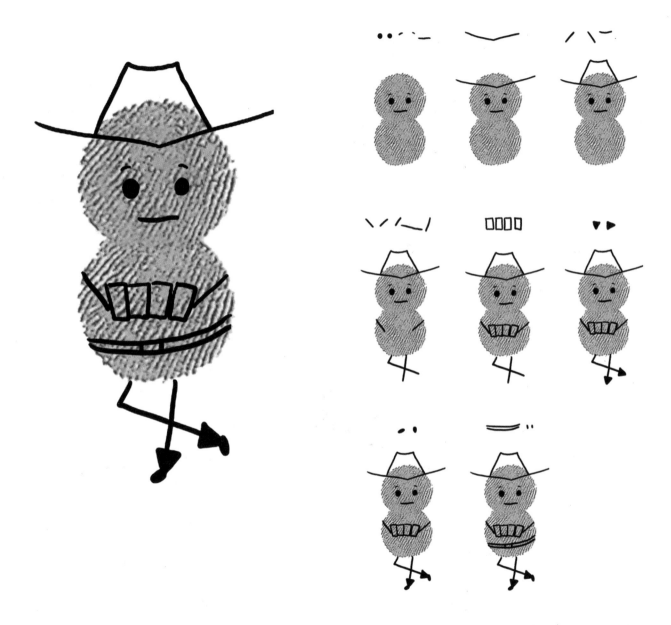

BANDIT GANG

BE AWARE OF BANDITS! THESE ARE NASTY CHARACTERS; THEY STEAL, PILLAGE, AND CHEAT.

THEY WEAR MASKS...

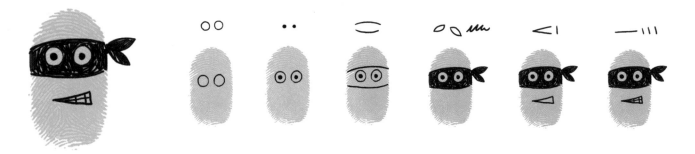

... AND STRIPED SWEATERS, SO THEY'RE NOT RECOGNIZABLE.

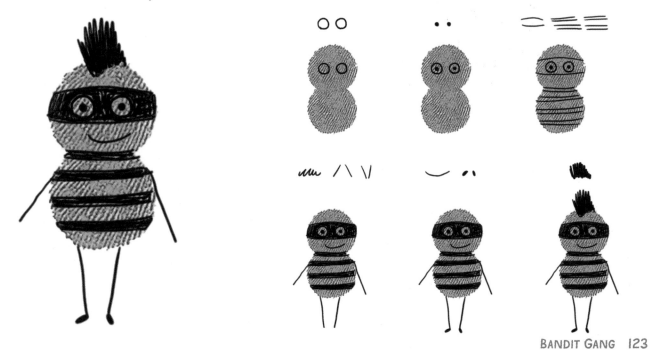

WHEN THEY HAVE THEIR BOOTY, THEY RUN AWAY FAST.

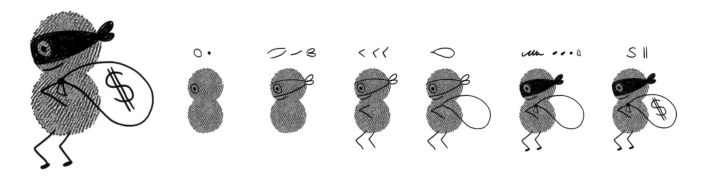

MOSTLY, THEY STEAL GOLD...

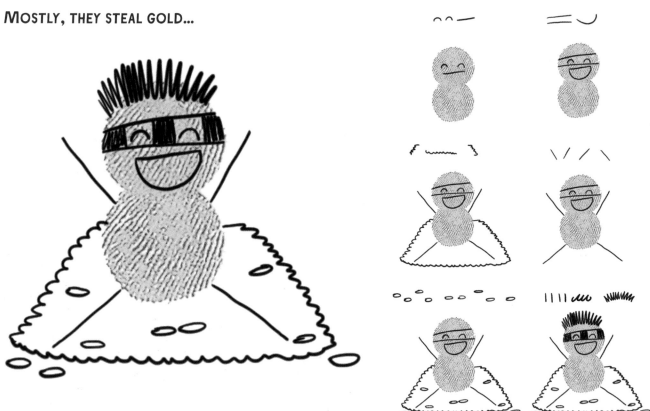

...FROM A SAFE.

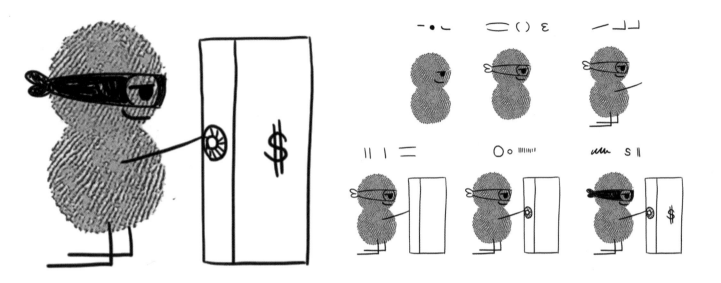

When they are caught, they get a ball and chain.

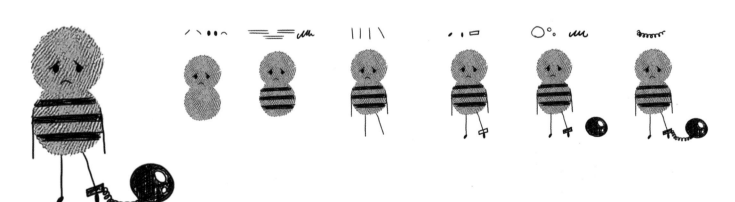

NIGHT TOUR

AT NIGHT ALL SORTS OF CREEPY CHARACTERS ARE OUT AND ABOUT.

WITCH

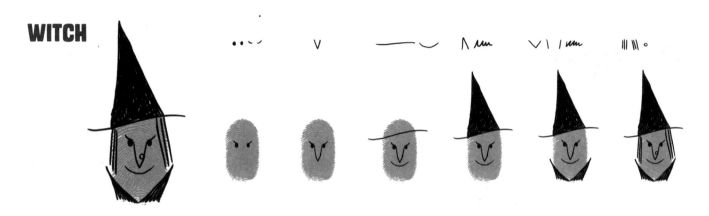

WITCH ON A FLYING BROOM

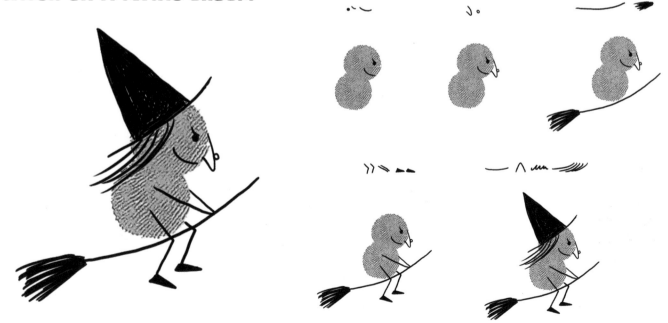

VAMPIRE

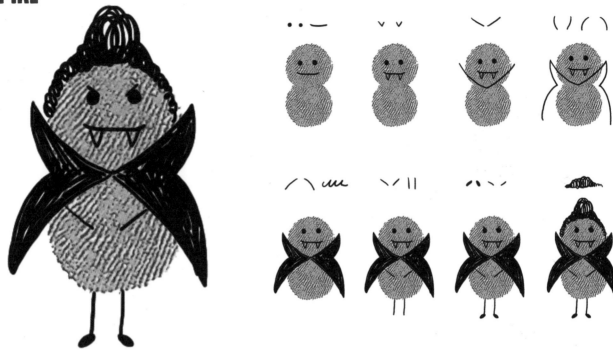

WEREWOLF

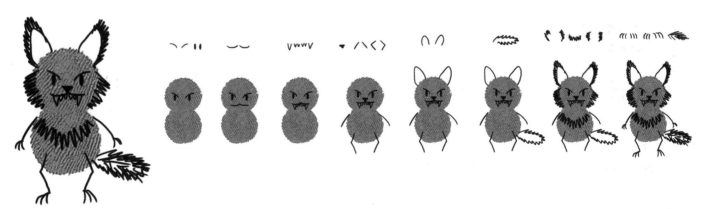

ZOMBIE

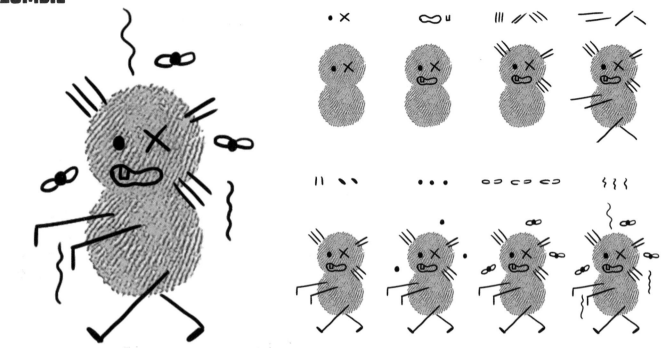

SKELETON

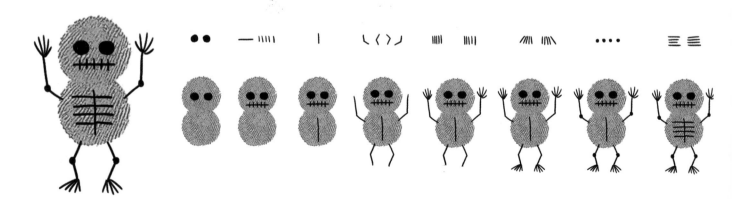

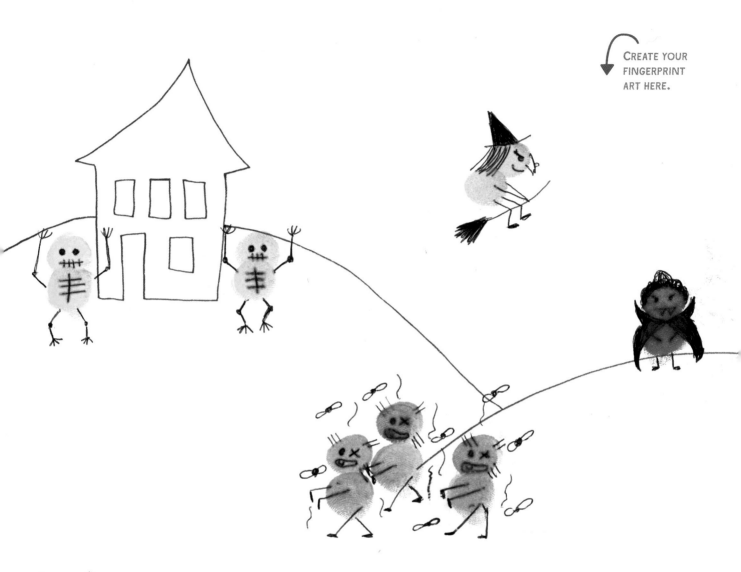

CREATE YOUR
FINGERPRINT
ART HERE.

— WHO'S THERE! —

DINOSAURS

A LONG TIME AGO DINOSAURS ROAMED THE EARTH. LOOK HOW DIFFERENT THEY WERE.

MANY WERE PART OF THE TYRANNOSAURUS FAMILY.

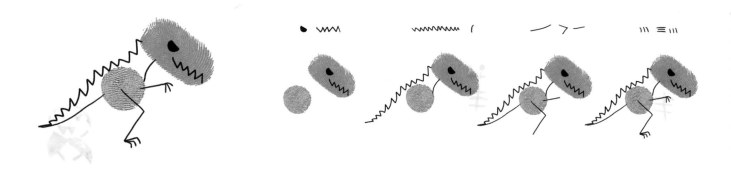

SOME DINOSAURS COULD FLY...

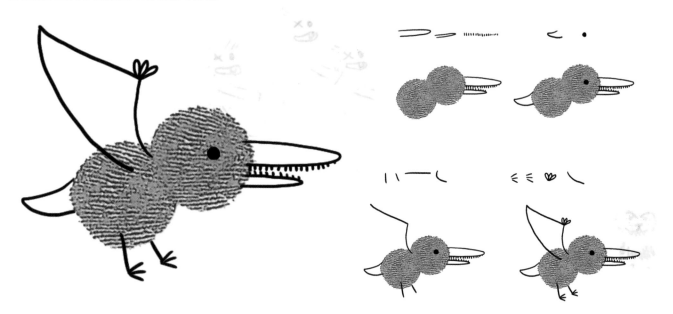

...OTHERS WOULD SWIM.

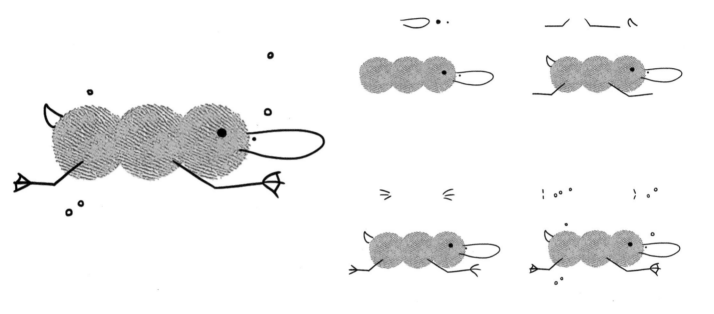

A FEW DINOSAURS WERE HERBIVORES...

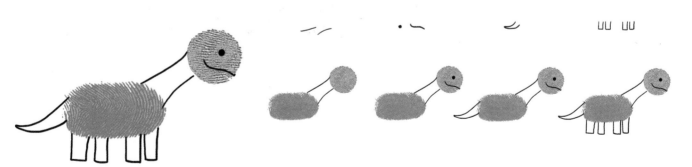

...OTHERS WERE CARNIVORES.

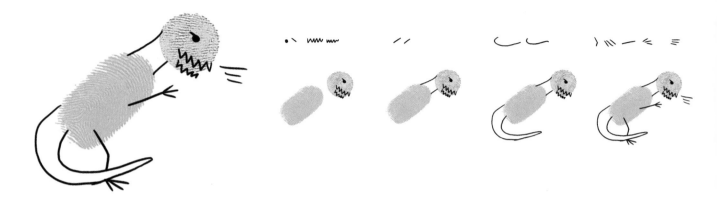

SOME LIKED TO SLEEP...

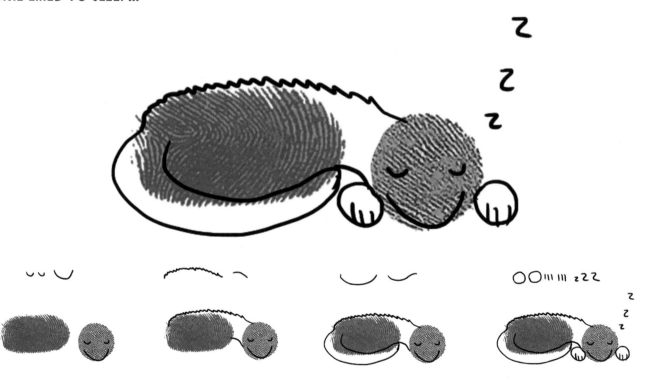

...OTHERS LIKED TO JUMP AROUND.

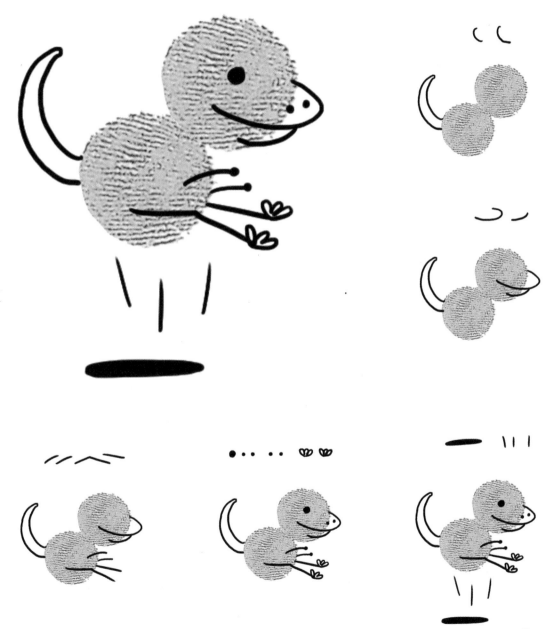

VIKINGS

THERE ARE SOOOO MANY DIFFERENT VIKINGS.

SOME VIKINGS WEAR HELMETS...

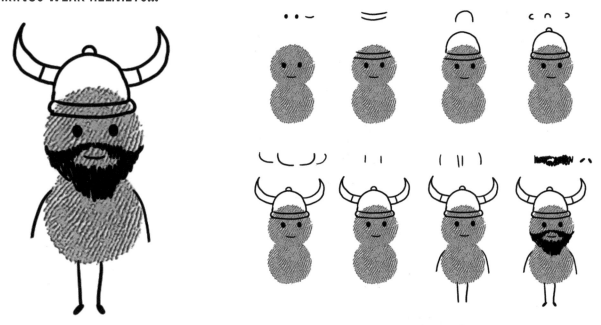

...OTHERS HAVE WEAPONS.

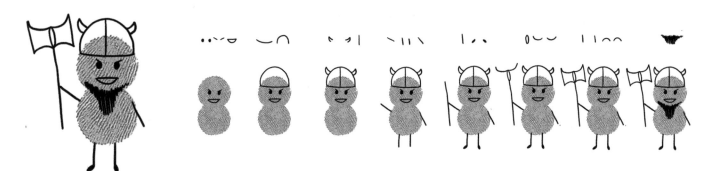

OFTEN THEY HAVE A SHIELD WITH THEM...

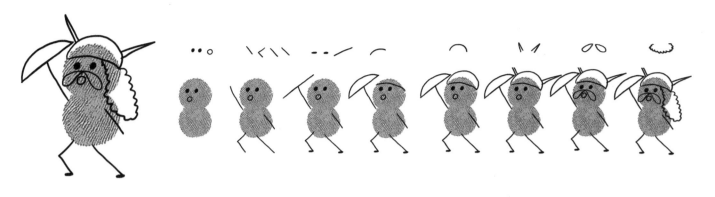

...OR A HORN.

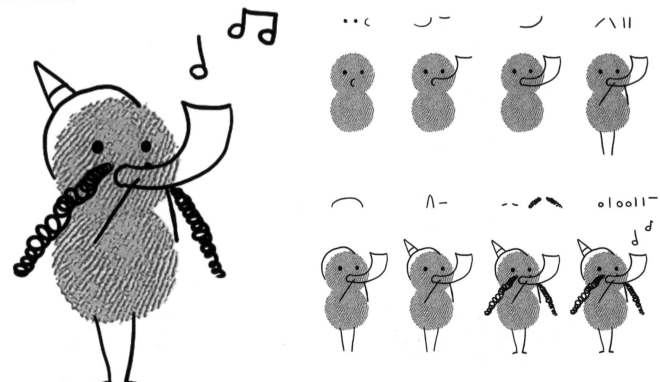

VIKINGS LIKE TO EAT DRUMSTICKS.

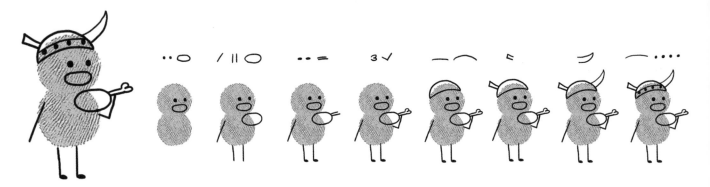

MANY HAVE THEIR OWN ROWBOAT...

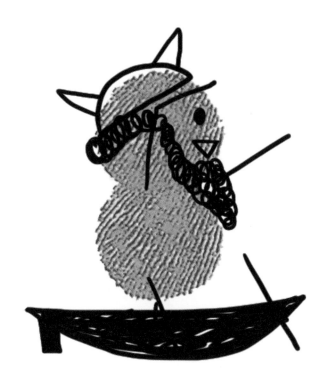

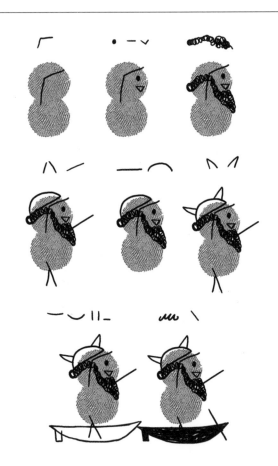

...FROM WHICH THEY THROW THEIR NETS TO CATCH FISH.

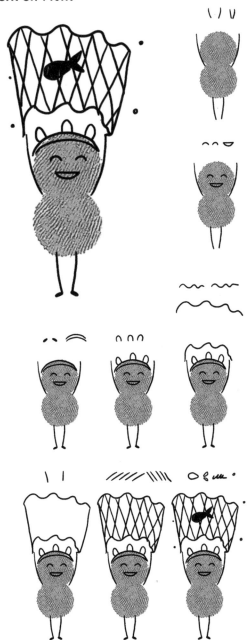

THERE ARE ALSO VIKING WOMEN WITH LOOONG HAIR.

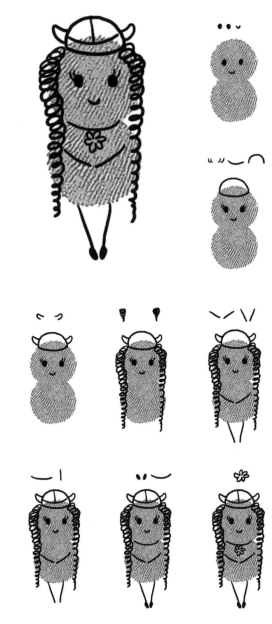

COMIC HEROES

COMIC HEROES ARE SMART, FAST LIKE THE WIND, AND HAVE SUPER POWERS!

SPIDER-MAN, THE SPIDERLIKE AVENGER

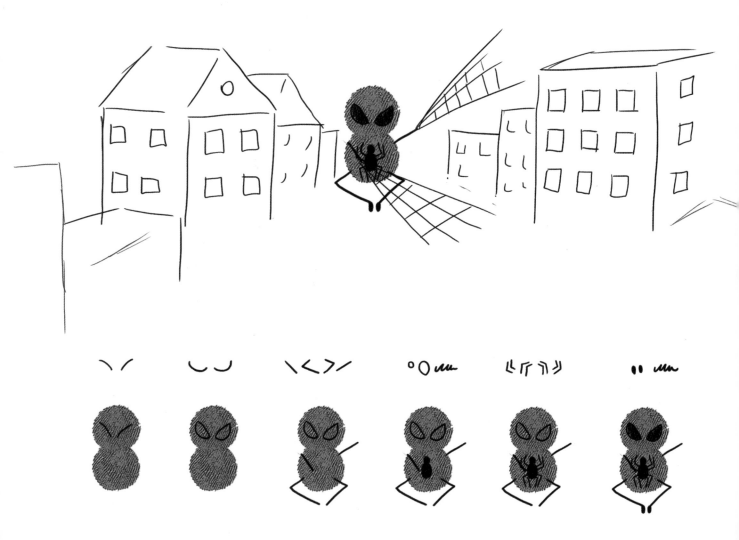

BATMAN, THE DARK KNIGHT

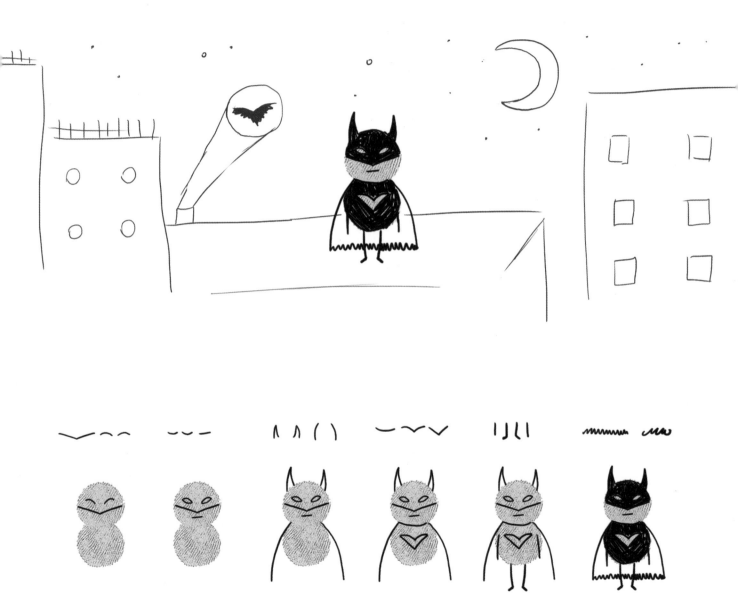

THOR, A HERO WITH A HAMMER

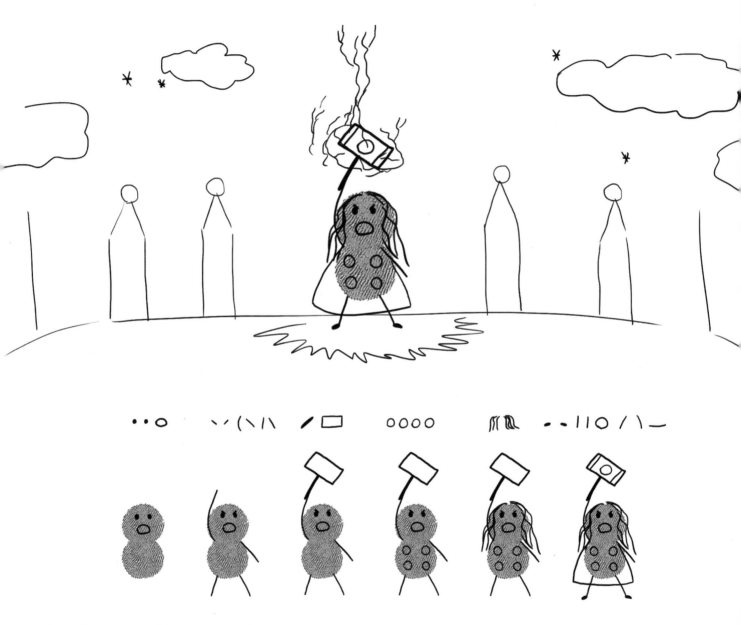

SUPERMAN, THE FLYING HERO

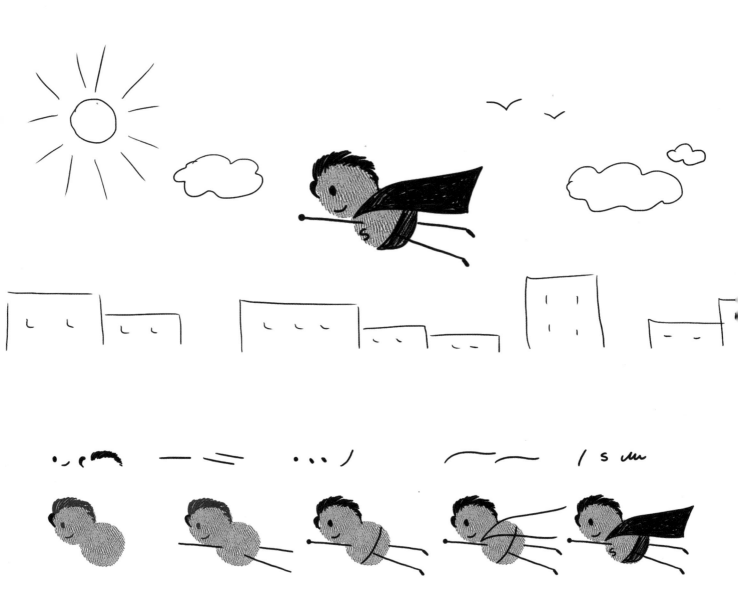

HULK, THE FRANTIC HERO

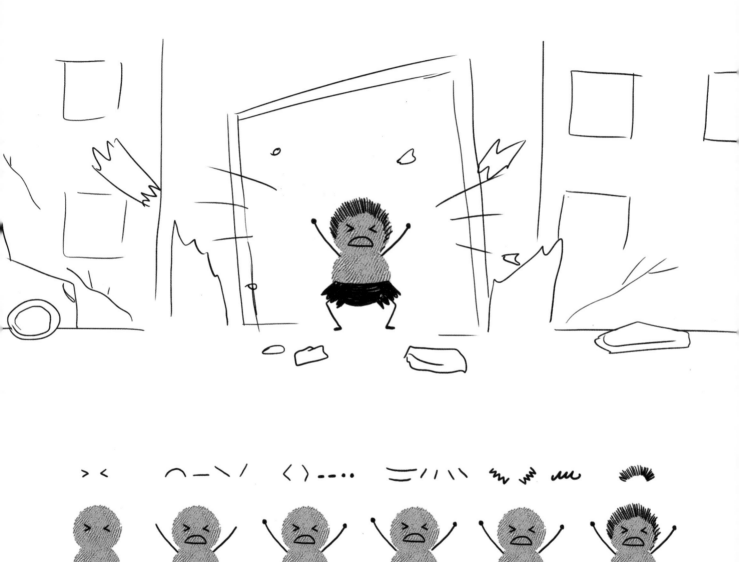

COMIC VILLAINS

BUT WATCH OUT, THERE ARE ALSO MEAN CHARACTERS!

CHARLES, THE CRAZY PROFESSOR

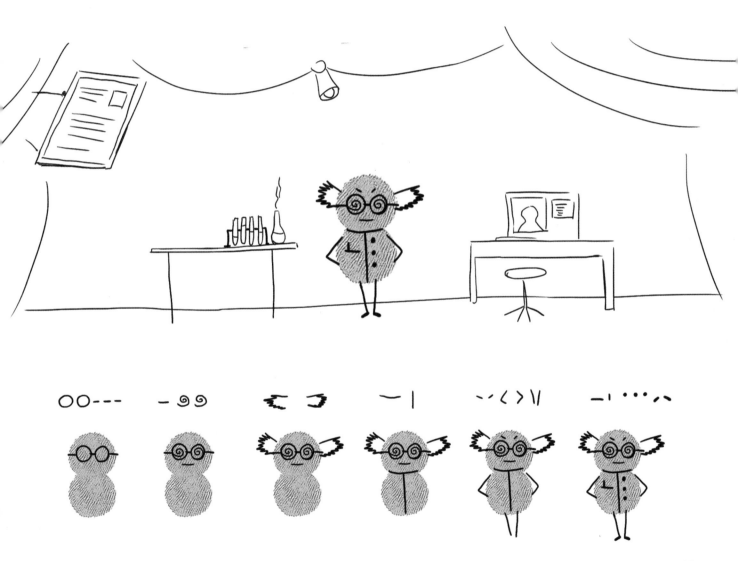

JOKER, THE GRINNING VILLAIN

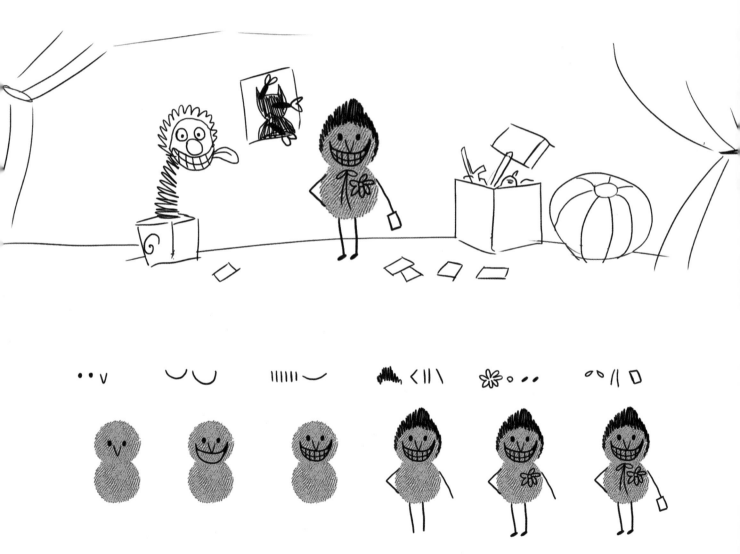

CATWOMAN, THE NASTY THIEF

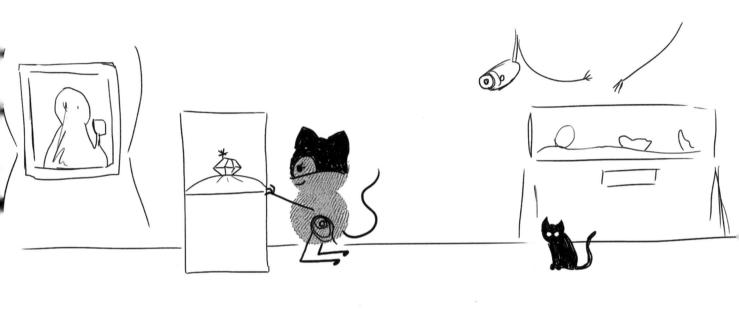

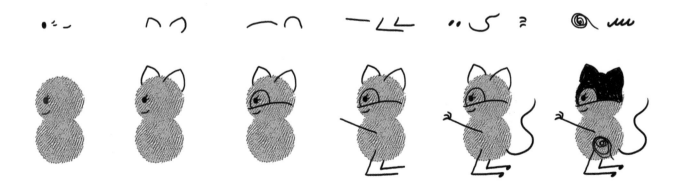

SPOOKY DÉCOR

GHOST

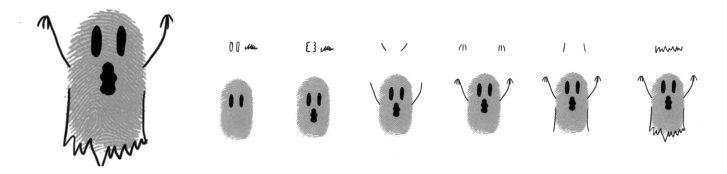

GIANT JACK-O'-LANTERN

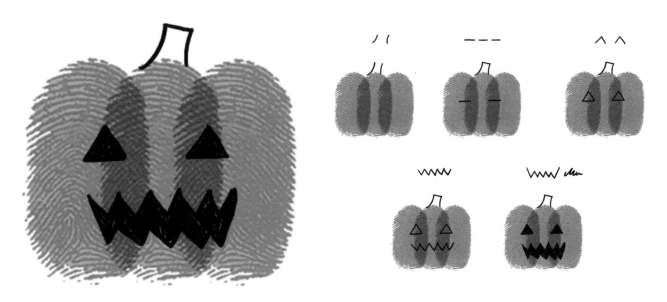

SMALL JACK-O'-LANTERN

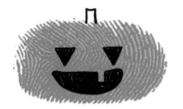

SPIDER

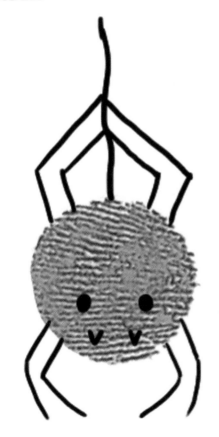 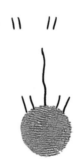 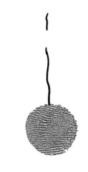 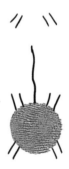

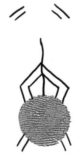 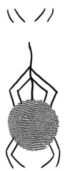 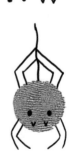

HANGING BAT

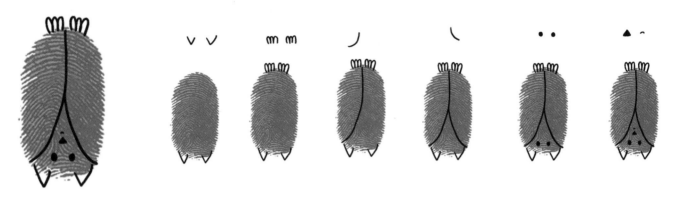

COFFIN

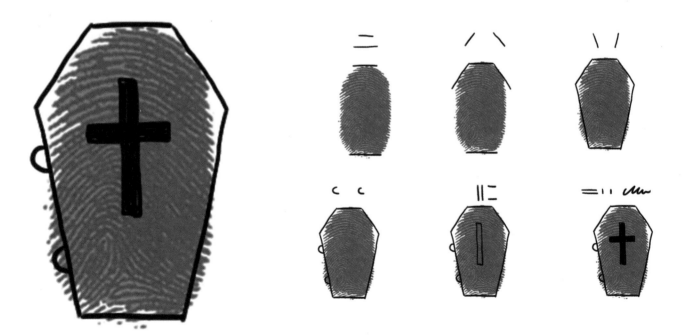

CANDLE

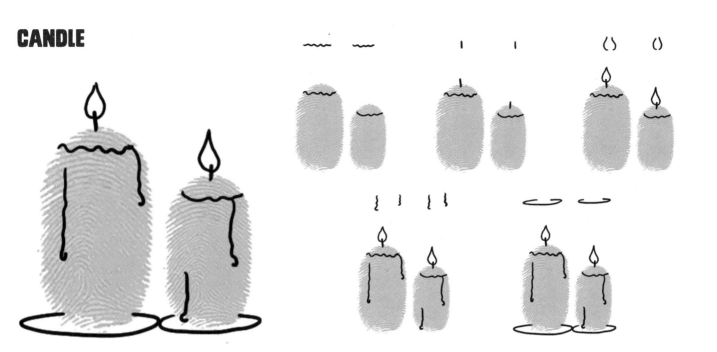

SKULL GARLAND

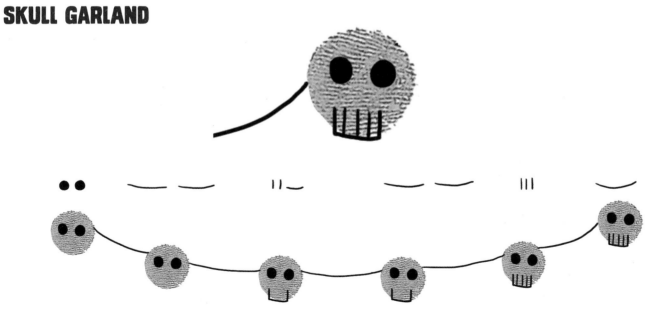

LITTLE HAND

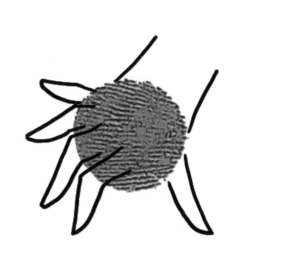

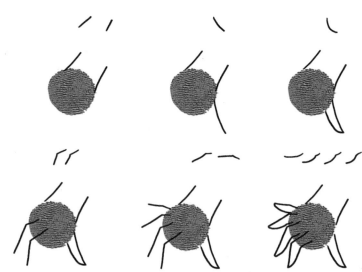

POTION

CREATE YOUR
FINGERPRINT
ART HERE.

DETECTIVES

DETECTIVES ARE SMART! LOOK WHICH INDIVIDUALS AND THINGS ARE HERE.

DETECTIVE

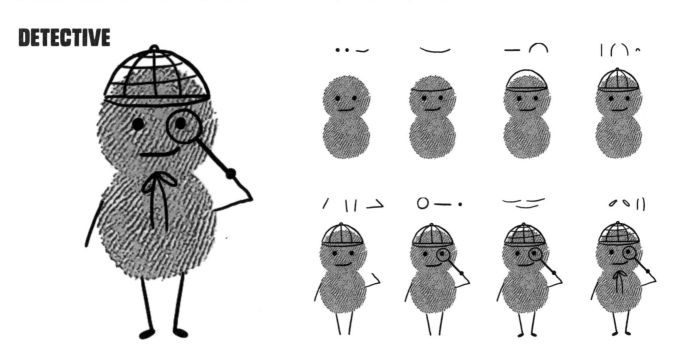

HIS ASSISTANT

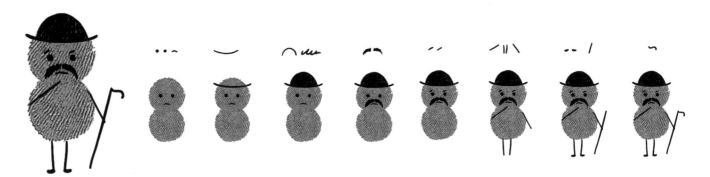

DETECTION DOG

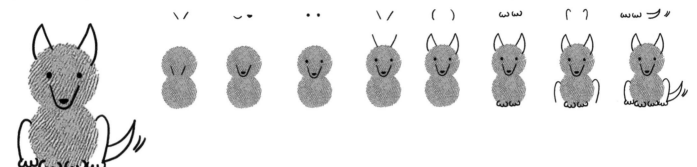

POLICE OFFICER

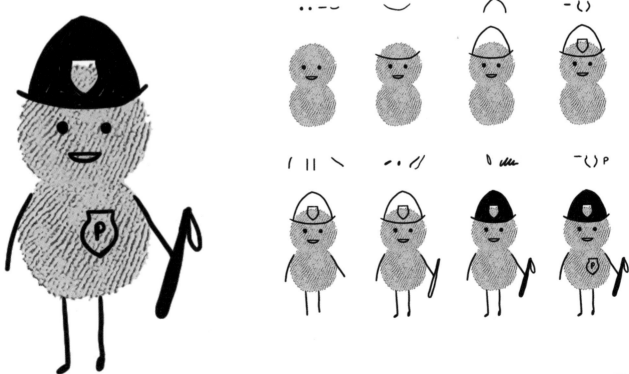

MAGNIFYING GLASS

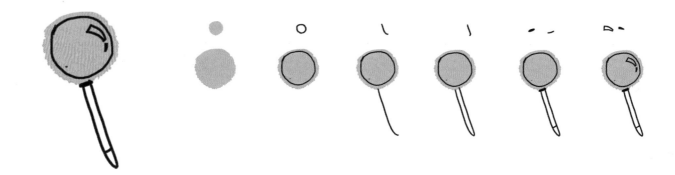

BINOCULARS

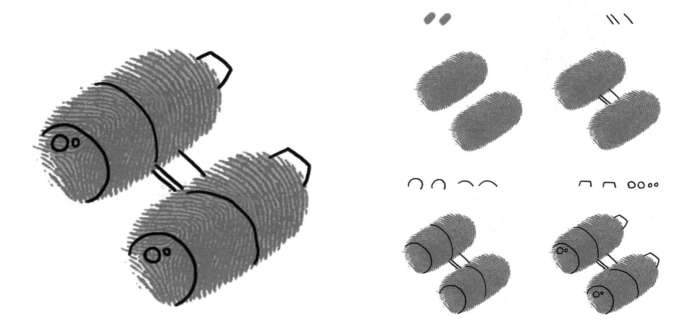

TELEPHONE

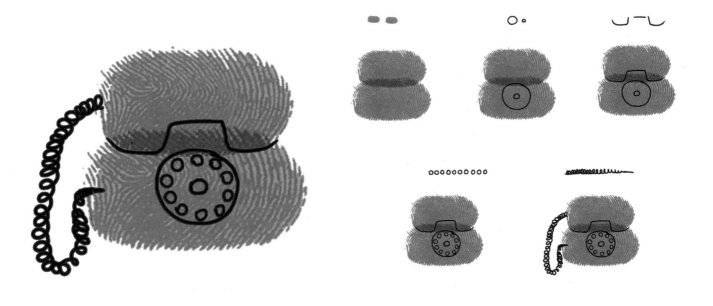

POCKET WATCH

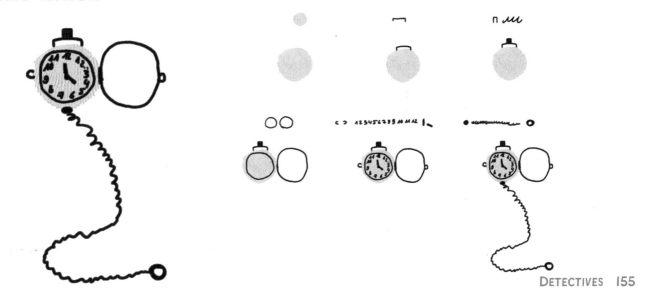

MASTER DETECTIVE

THE MASTER DETECTIVE PICKS UP THE TRAIL OF A CRIMINAL.

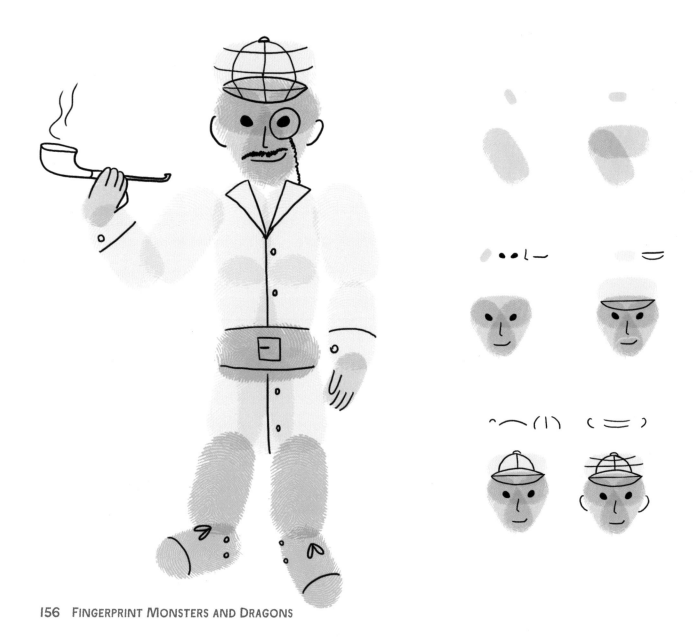

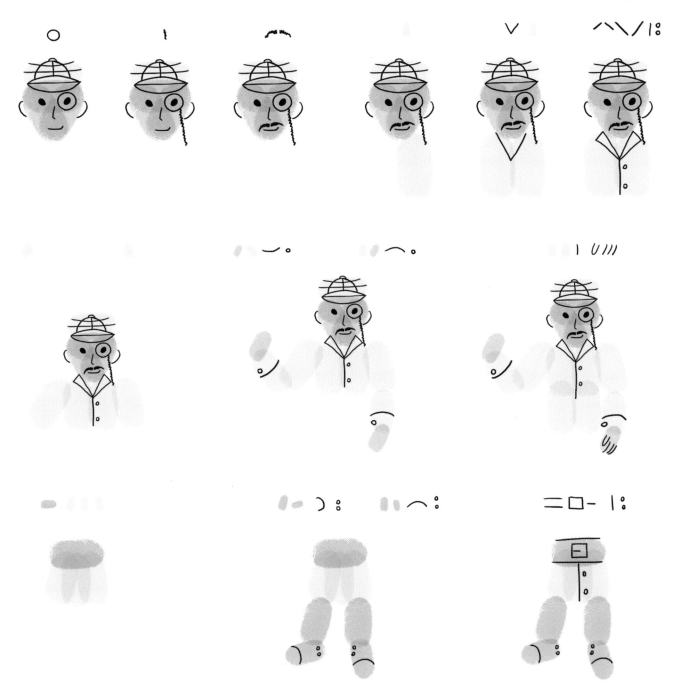

CREATE YOUR
FINGERPRINT
ART HERE.

Quarto is the authority on a wide range of topics.

Quarto educates, entertains and enriches the lives of our readers—enthusiasts and lovers of hands-on living.

www.quartoknows.com

First published in the United States of America in 2016 by
Quarry Books, an imprint of
Quarto Publishing Group USA Inc.
100 Cummings Center
Suite 406-L
Beverly, Massachusetts 01915-6101
Telephone: (978) 282-9590
Fax: (978) 283-2742
QuartoKnows.com
Visit our blogs at QuartoKnows.com

10 9 8 7 6 5 4 3 2 1

ISBN: 978-1-63159-141-9

Digital edition published in 2016
eISBN: 978-1-63159-203-4

Cover: Debbie Berne
Illustrations: Ilona Molnár
Editorial staff: Natascha Mössbauer, Silvia Keller, and Ilona Molnár
Scene Illustratrations: Marissa Giambrone
English translation: Anne Re

Printed in China